THE *Art* OF DESIGNING WATERCOLORS

by Robert Lovett

international
artist

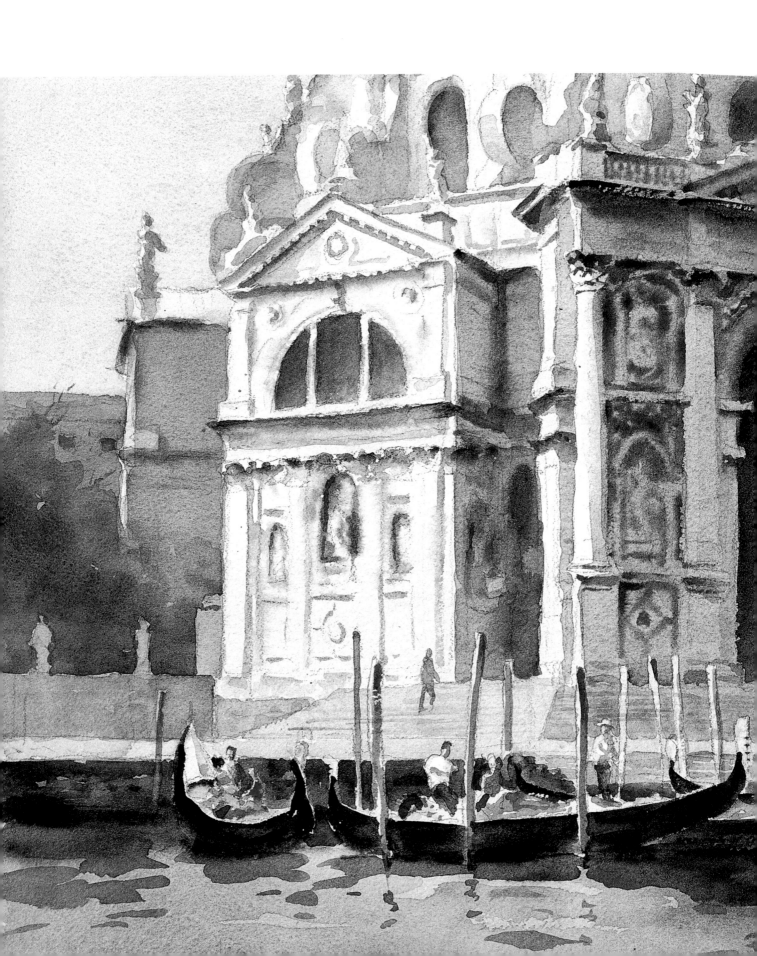

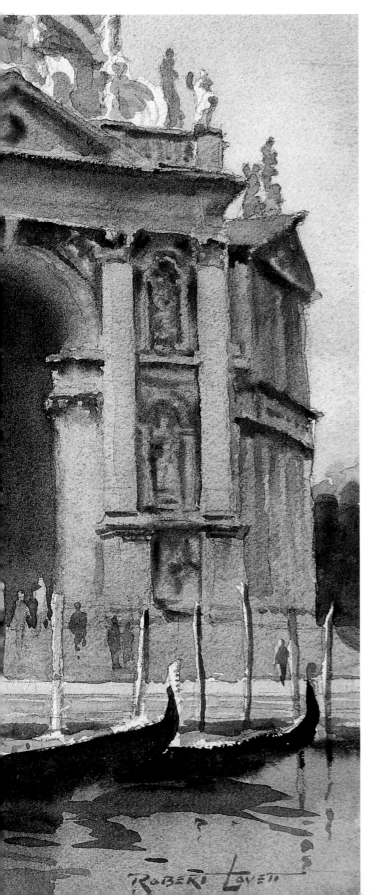

THE
Art
OF
DESIGNING
WATERCOLORS

by Robert Lovett

international
artist

'SANTA MARIA DELLA SALUTE, VENICE'

international
artist

International Artist Publishing, Inc
2775 Old Highway 40
P.O. Box 1450
Verdi, Nevada 89439
Website: www.international-artist.com

Edited by Terri Dodd
Designed by Vincent Miller
Photography and illustrations by
Robert Lovett www.lovettart.com
Typeset by Ilse Holloway and Cara Miller

ISBN 1-929834-14-4

Printed in Hong Kong
First printed in hardcover 2002
06 05 04 03 02 6 5 4 3 2 1

Distributed to the trade and art markets
in North America by:
North Light Books,
an imprint of F&W Publications, Inc
4700 East Galbraith Road
Cincinnati, OH 45236
(800) 289-0963

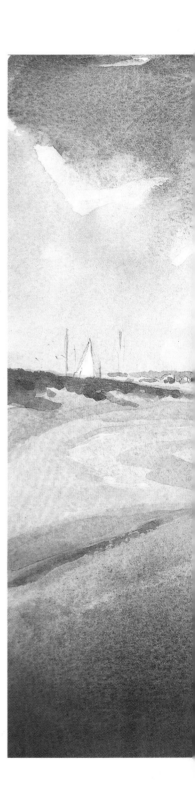

Acknowledgments

This book is dedicated to my wife Joan who has given me steadfast support and encouragement. Joan is my constant companion and assistant — she managed my art gallery for seven years, and handled all the promotion, marketing worldwide and exhibitions. Along the way we have had loads of fun.

To my sons, who have followed in my footsteps, and to my grandchildren who have also followed and win many awards with so much talent.

Thanks to all my clients and wonderful friends who have supported me over the years.

Thanks to *International Artist* magazine Publisher, Vincent Miller and Editor/Executive Publisher, Terri Dodd, who have helped and encouraged me put this book together.

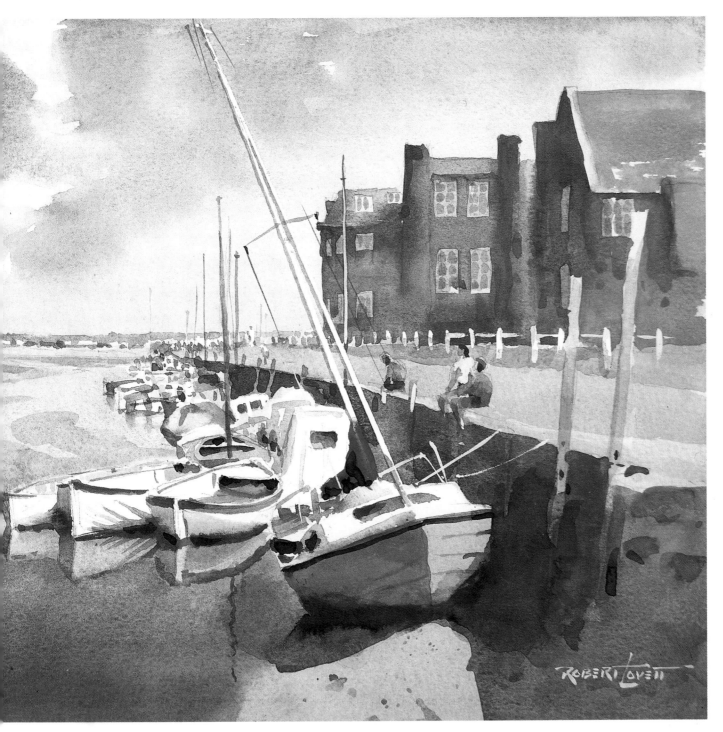

'LOW TIDE, BLAKENEY, NORFOLK, UK'

Contents

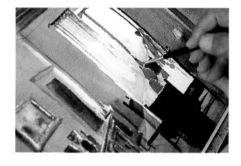

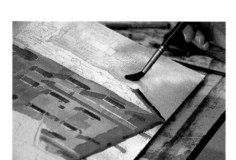

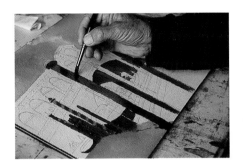

Part 4

Using all the tools and arrangements of design

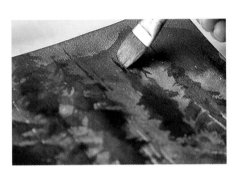

Part 5

Designing for different subjects

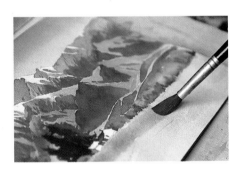

Introduction

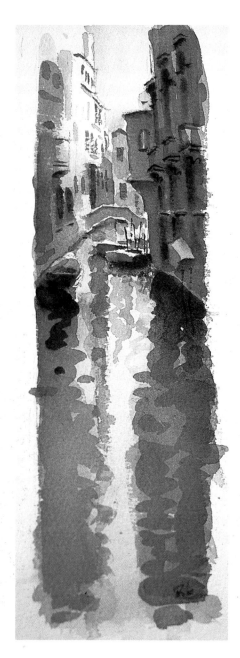

It is now fifty-four years since I first took up a watercolor brush. At seventeen I was captivated by the medium. At seventy I derive great pleasure and satisfaction from the skills I have developed. It never ceases to challenge and delight. The learning process never ends. There is always something new to try.

In the early years I struggled and made many mistakes. I didn't know how to find a subject or how to compose one when I did.

I tore up my many failures but I was never sufficiently discouraged to quit. I suffered from a lack of knowledge and experience and therefore a lack of confidence. In those days (the late 1940s) there was little opportunity to learn. There were no workshops or seminars and very few helpful books. Those that were available were very expensive for a teenager early in his working life. I am not just trying to tell you how tough it was. I also scored my share of successes, enough to encourage me to keep going. My purpose in telling you this is to let you know that it is not necessary to go through such an experience. Help is at hand.

I see many of my students going through the same traumas, making the same mistakes and becoming thoroughly disheartened. I try to reassure them that this is common and that I had exactly the same problems. I tell them that I can help them to avoid the pitfalls and learn from *my* mistakes. It is not a quick fix or a miracle formula. It requires dedication and enthusiasm. There is a lot of work to be done. Those who are prepared to do this make remarkable progress.

So the aim of this book is to help you bypass the mistakes and fast track the learning process. Watercolor is a medium fraught with accidents. This is the nature of it. You will learn to contrive and control these beautiful accidents. Even more important, you will learn to design your picture, to place every element correctly in relationship to the whole. This is not just another book on watercolor but a vehicle to inspire you, to raise you to a higher level, to give you confidence to paint bold and dynamic watercolors. The more skill and knowledge you acquire, the more pleasure you will derive from your work. Use this as a reference book. It is not intended to be read for your entertainment in the comfort of your reclining chair but as a tool to solve your problems as they arise. It should be at your side while you are painting and digested slowly as you work. As your understanding increases, the value of this information will become more and more apparent.

So here is an offer to take advantage of more than half a century of experience all rolled into one little book.

I wish I had a book like this fifty years ago!

Robert Lovett.

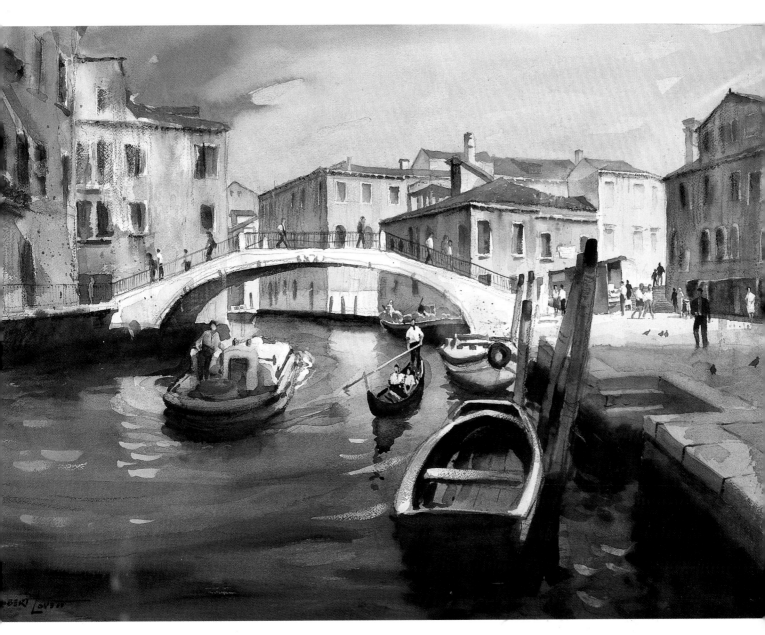

'RIO DI CA FOSCARI, VENICE'

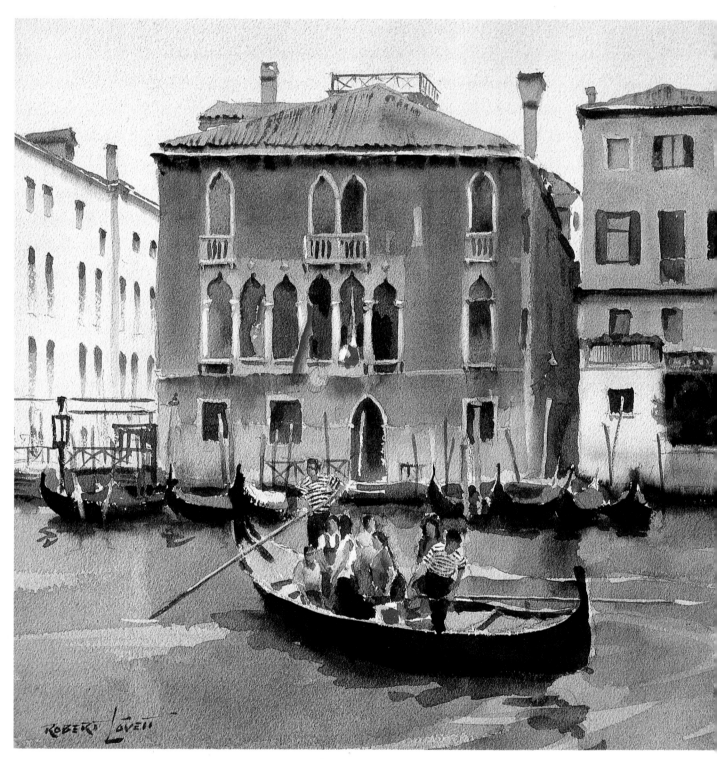

'THE FISH MARKET FERRY, VENICE'

Getting ready

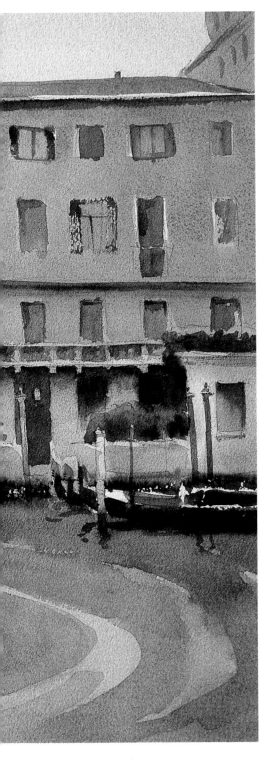

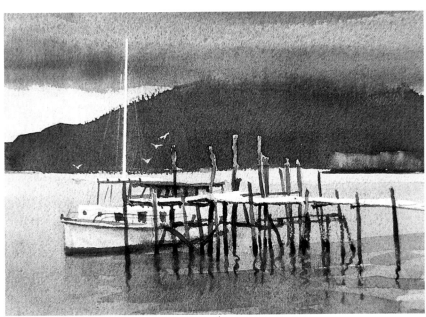

'OLD JETTY, HINCHINBROOK, AUSTRALIA'

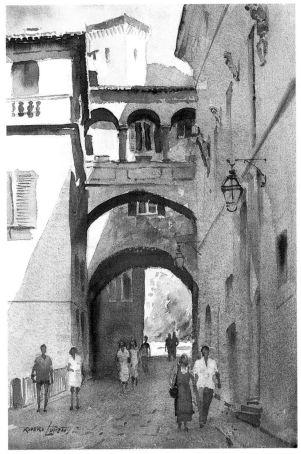

'ARCHES OF
SPOLETO, ITALY'

Equipment and materials

Using the finest materials makes the job so much easier.

Every artist finds a working environment, and assembles equipment and materials that suit their needs. You will find by experiment and from experience what is best for you. However there are certain important requirements that are common to everyone. I believe we need all the help we can get, and using the finest materials makes the job so much easier.

Paper

Use the best quality paper and paints you can find. Compromising quality for price is a big mistake. It is difficult to paint watercolors with inferior materials and the end result will suffer.

Watercolor paper must be acid free. One of my favorite papers is Arches 300gsm, either cold pressed or rough.

Cold pressed has texture but takes detail fairly well. Rough, as the name suggests, has a more pronounced texture for broken edges and dry brush effects. Hot pressed paper is smooth and more difficult to work on, although it is certainly worth trying. Full sheets can be stretched by soaking in water before wrapping around a board and pinning to the back. The paper dries taut and is a delight to work on. The heavier papers can be used unstretched but there is a certain amount of buckling. This can be a problem when it comes to framing. My advice is to experiment with many different papers.

Brushes

Use good brushes. You don't need to buy the most expensive, but don't buy the cheapest either. I like to use the largest possible brush for the job.

For laying in large washes I generally use squirrel hair flat 2" or round No 12. I find sable flats 1" and ½" useful for working flat on rough paper to produce broken edges and broken washes.

Most of my work is done with round pointed sables varying in size from 0 to 12. These are all-purpose brushes but especially good for defined brushstrokes and calligraphic effects. I also use a small bristle brush for washing out.

Palette

Use a palette that has large mixing areas and paint wells that will take a generous amount of paint.

You have to be liberal in your use of paint — it will be worth the extra money spent. If you want to make bold dynamic watercolors, you must have lots of paint on your palette.

Colors

My palette consists of the following colors:

Ultramarine Blue	**Cadmium Red**
Cobalt Blue	**Alizarin Crimson**
Cerulean Blue	**Rose Madder**
Phthalo Blue	**Indian Red**
Viridian	**Raw Sienna**
Aureolin	**Burnt Sienna**
Cadmium Yellow	**Indigo**
Yellow Ochre	**Mineral Violet**
Windsor Yellow	

That is quite a range of colors but only a very few of them would be used in any one painting. No doubt you will experiment and add and discard colors to suit yourself. There will be more on color later.

A few other accessories are necessary. Some 2B pencils, a sharp knife, a natural sponge and some tissues.

The way to banish tentative, weak, disappointing work is to practice often

Watercolor is sometimes referred to as a difficult medium. However, those characteristics that make it difficult are also what make it fascinating.

What is required is an understanding of these qualities — and lots of practice. I'm going to emphasize the importance of practice again and again. Anyone who plays a sport must practice. Anyone who plays a musical instrument must practice. Singers and actors must rehearse. Watercolor is no different. It is a skill that requires constant practice.

Even after so many years I still need to practice and loosen up before beginning to paint. In fact it can take several days to become "tuned in" if I've had a long break from the medium.

Practice builds confidence

I frequently see amateur artists stand before a beautiful, clean sheet of expensive watercolor paper with the intention of painting a "picture". They soon become discouraged by the poor result. Their work is tentative and weak.

Practice dispels inhibition and builds confidence. You must learn the skills in order to have control over the medium. You must practice to loosen up every time before attempting a painting. The techniques must become second nature so that you can concentrate on the main objectives such as the design and the message or mood. A painting must communicate more than just an image of an object.

Become fearless

To avoid worrying about wasting expensive paper you need lots of cheaper paper on which to practice. I don't mean poor quality paper, but a paper that responds at least somewhat like your "real" paper. If you shop around you can buy fair quality paper at a reasonable price. Bear in mind that you can use both sides of the sheet which, in effect, halves the price so you can make lavish use of your paper and practice, practice, practice.

The same applies to your pigments. You must become liberal in their use. Your inhibition will not go away if you are stingy with paint.

The only way to master the techniques is by doing and experimenting. Listening and watching is OK, but only by doing it for yourself will you learn the subtleties of controlling the medium.

There is a lot to learn, but **practice is fun** because mistakes don't matter. Embrace the mistakes, that is how you learn. You must enjoy the process and achieve satisfaction from your progress.

If there is one thing I want you to achieve it is **confidence** in yourself. You will approach your work with more freedom and watercolor will become a joy to experience

The whole business of painting watercolor should always be fun. You must avoid the inhibitions caused by being too serious. So what if you mess up a few pictures! Everybody does. The main thing is that you learned something from the experience.

Well, after all the practice you should have developed a feeling for the medium. No doubt you are fired up to get on with the real stuff. There is however one serious matter we must attend to and that is DESIGN.

How to practice

- Instead of making a preliminary drawing, draw with your brush.
- Try suggesting a sky, a hillside and then a few trees. This can be all one wash, wet-into-wet.
- Do the same with wet wash over dry.
- Keep the shapes simple masses.
- Do not become inhibited by the subject but retain the free approach.

Exercises are simply about technique, they are not about design or a realistic interpretation.

Well, did you get bored doing the practice? I think not. It's a lot of fun. Now you have some confidence you can start to introduce little hints of subject matter into your doodles.

My workplace is comfortable and pleasant. In the northern hemisphere it is the north light that is prized and sought-after for the artist's studio. However, because I live in the southern hemisphere, the optimum light is south light. My very high, south facing window floods my table with cool light, direct from the sky.

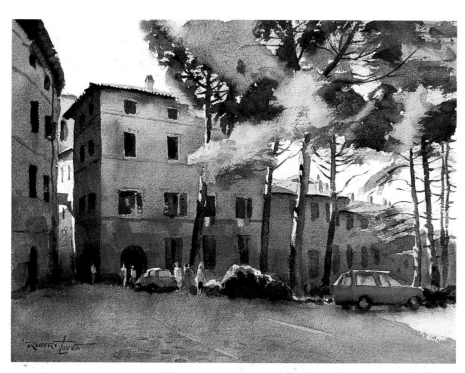

'PINES OF SPOLETO, ITALY'

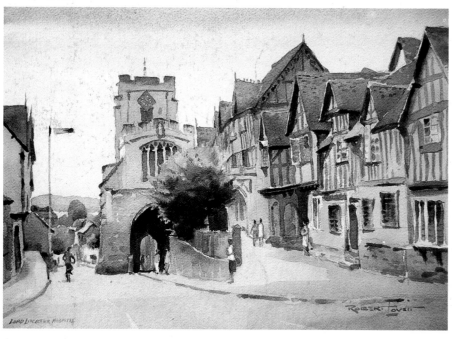

'LORD LEYCESTER HOSPITAL, WARWICK, UK'

Part 2
Understanding the 'how' and 'why' of design

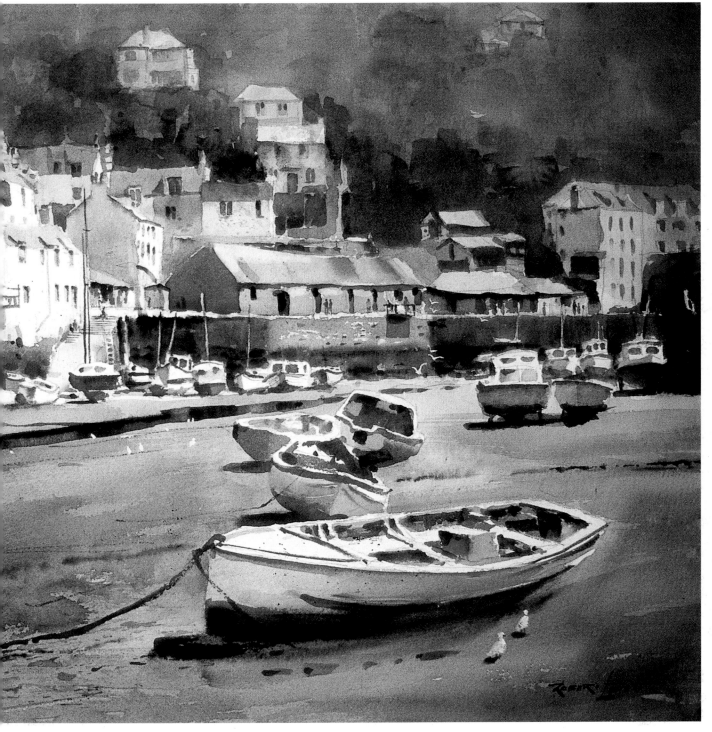

'LOW TIDE, POLPERRO'

Chapter 2

The 'how' and 'why' of design

The 15 things you should know, explained and illustrated.

This chapter on design will have an influence on everything that follows throughout the book. Although I deal with techniques and many other aspects of watercolor, all the decisions you make will be affected by the design guidelines learned in this chapter. Even if you have mastered drawing and technique, knowledge of design is crucial. Picture making is all about design.

First, it is essential to recognize a subject. Then you must learn to put the picture together. Once you work with design guidelines in mind, decisions about what to emphasize, what to leave out, and what to change, become clear.

Your goal is to become adept at arranging the shapes, colors and tones within the picture area to make a pleasing pattern, be it a realistic representation or an abstract work. It's all the same.

If you have been painting for some time and have learned a little about composition, drawing and technique, but you feel there is something lacking, then using design skills will thrust you into a new way of seeing. This is exciting stuff, and well worth the effort to learn. So let's get started.

The How and Why of Design
The tools and arrangements (the how and why) of design have not changed for centuries. It is essential that you have this knowledge. However, I would like to point out right at the start that what I am going to tell you is not a list of inflexible rules that will inhibit your creativity. On the contrary, they are guidelines you can use to help create wonderful pictures.

You only need to work with seven TOOLS (the marks you place on the paper) and eight ARRANGEMENTS (the way you place those marks on the paper). That's all.

The How
The HOW represents the TOOLS which are the *MARKS YOU MAKE ON THE PAPER.*
There are 7 TOOLS, they are:
1. Line
2. Shape
3. Tonal Value
4. Size
5. Color
6. Texture
7. Direction

The Why
The WHY represents the ARRANGEMENTS the way you *LAY OUT THE MARKS ON THE PAPER.*
There are 8 ARRANGEMENTS, they are:
1. Unity
2. Contrast
3. Dominance
4. Repetition
5. Alternation
6. Harmony
7. Gradation
8. Balance

1. LINE
The simple line is the most versatile mark you can use. A line can be thick or thin, long or short, curved or straight, broken, suggested or implied. It can direct the eye. Line can divide, form a barrier, serve as an outline and even suggest form.

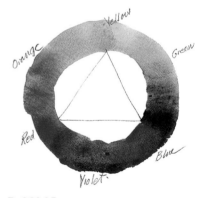

5. COLOR
Whereas tone must be correct, color allows great latitude, providing the opportunity for creative and more exciting use of color.

You can see from the color wheel illustration how every color is derived from the three primaries — yellow, red and blue.

In between are the secondary colors — orange, green and violet, made by mixing the two adjacent primaries.

The How — The 7 Tools of Design
The marks we place on the paper

These are the physical marks we have at our disposal, that we place within the rectangle or square represented by our paper.

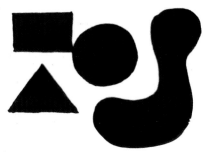

2. SHAPE
When we move from using line to using space we have shapes. Designs are made up of many shapes of various sizes, colors, tones and textures.

3. TONAL VALUE
Tonal value (or tone), depicts the lightness or darkness of a shape. Tonal value may be constant or gradated within the shape. In watercolor the range goes from black to white. The white of the paper is the highest light. Of course nature goes much higher up the scale but we have to work within those limitations. A painting can exist in tone alone (monochrome) and is not dependent on color. It is critical to have the tonal values correct.

4. SIZE
To create interest and avoid monotony it is good design to vary the size of shapes and the spaces between them.

6. TEXTURE
In addition to tonal value and color, texture may also add interest within a shape. Texture can be even or gradated. It may be used to describe the surface of objects.

7. DIRECTION
Direction is the vehicle you use to guide the eye through the design. Lines and shapes can be vertical, horizontal or oblique. Directions can express feelings and emotions. Vertical may suggest grandeur and poise. Horizontal can evoke a feeling of calmness and serenity. Oblique can imply movement or, when used with opposing obliques, can suggest tension or chaos.

Color is affected by light and shadow, by atmosphere and the surrounding environment. It cannot be considered as a separate, static entity. Color is dependent on tone. Tone is not dependent on color. Each color or nuance of color must retain its identity, from the highest light through to the deepest shadow. However, it can be influenced by color reflected from the surroundings.

Where contrast is extreme you may sometimes have to resort to leaving (reserving) white paper for the highest light.

The 7 Tools of Design in Action

THE MAIN TOOL USED HERE
LINE
'RICE HARVEST, BALI'

This painting demonstrates the use of
LINE to achieve unity by dominance.

The strong oblique line of the figures
is the most powerful element in the
design. The line dividing the two areas
of strong contrast (trees and rice field)
is the next most prominent feature.

DESIGN PLAN

The illusion of space and depth is created
by overlapping the figure shapes and
reducing them in size as they recede
from the foreground picture plane.

The painting was done with crisp,
dry, crackling edges. You can almost
feel the heat of the midday sun.

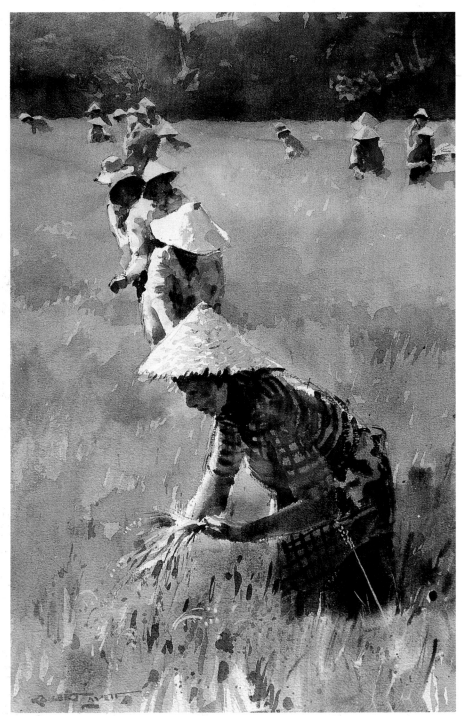

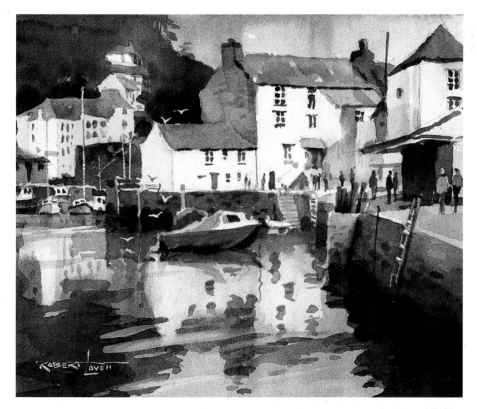

**THE MAIN TOOL USED HERE
SHAPE
'POLPERRO'**

EXERCISE
Analyze the SHAPES in this picture. The most obvious are the rectangular faces of the buildings because of the extreme tonal contrast used. These shapes are repeated softly in the reflections. However the entire rectangle consists of shapes. See the dark areas in three of the corners. Notice how they all connect and interlock. All shapes are repeated and vary in size to create dominance. A very pleasing abstract pattern has been created by arranging the shapes in this way.

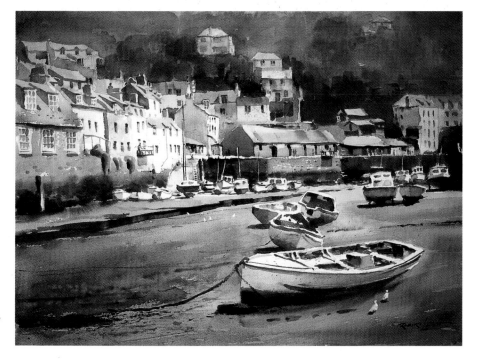

**THE MAIN TOOL USED HERE
SHAPE
'LOW TIDE, POLPERRO'**

DESIGN PLAN
Again, SHAPE is the star. This is also an example of a visual pathway. Notice how some of the boats and buildings are illuminated, inviting the eye to follow across the boats like stepping stones, and then move up into the buildings before exploring other parts of the painting. This is one way to exploit the principle of contrast. There are many ways to create a visual pathway using other design principles.

The 7 Tools of Design in Action

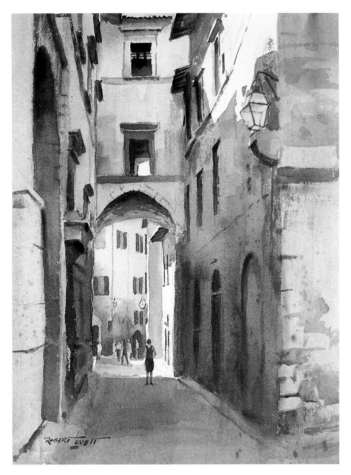

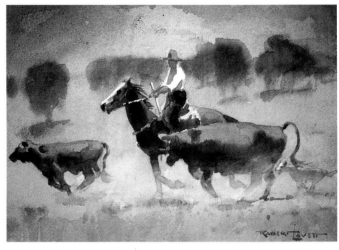

THE MAIN TOOL USED HERE
SIZE
'ROUNDUP'

The difference in SIZE of the dark masses gives dominance and unity, as well as creating variety to avoid monotony. See how the design is balanced by setting the largest object near the center and the lesser ones further out.

THE MAIN TOOL USED HERE
TONAL VALUE
'ARCHWAY, SPOLETO'

The eye is instantly drawn to the center of interest because the darkest and lightest tones are positioned there.

The lines of perspective all converge to the focal point helping to create the sensation of depth and distance.

DESIGN PLAN

This painting is totally reliant on tonal values for its success.

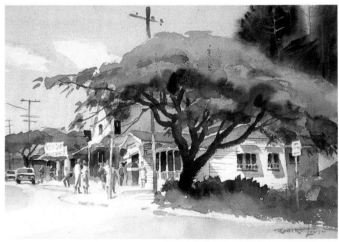

THE MAIN TOOL USED HERE
COLOR
'BUDDERIM POST OFFICE'

This would be a dull painting if it were not for the repeating reds sprinkled across the middle ground.

The dominant color is gray-green. By using a small area of complementary (red) and small areas of white, (tonal contrast) vitality is preserved.

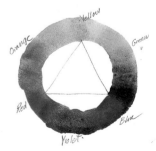

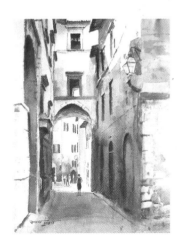

TONAL PLAN

Analyze the tones in this painting.

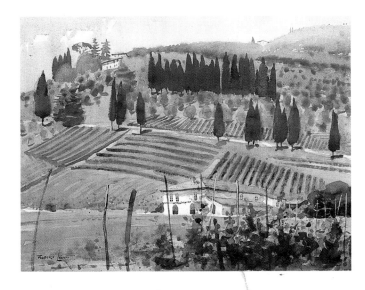

THE MAIN TOOL USED HERE
TEXTURE
'PATTERNS OF TUSCANY'

The repeating spots of the olive trees and the rows of the vineyard build a pattern of TEXTURE over a greater part of the picture.

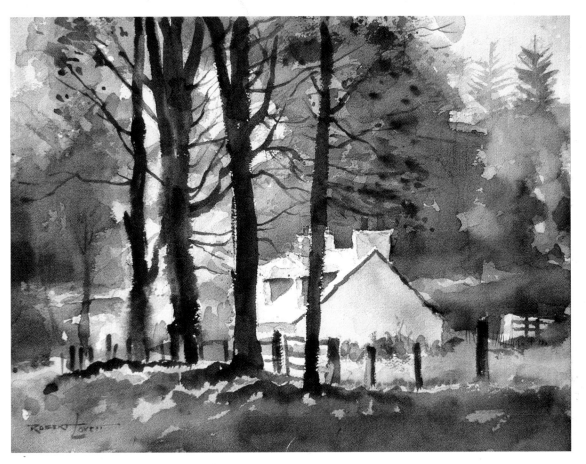

THE MAIN TOOL USED HERE
DIRECTION
'COTTAGE AT GLENUIG, SCOTLAND'

Repetition of the strong vertical tree trunks and the fence posts imposes dominance of direction and gives unity to the picture.

Contrast in DIRECTION is found in the horizontal at the base of the trees and the oblique roof lines of the cottage.

DESIGN PLAN

The dominant mid-tone contrasts with the light of the cottage and the darks of the tree trunks. Notice the texture of the tree trunks. Most have rough edges (dry brush) but some are softened (wet-into-wet) giving a little contrast. Those dense dark lines then become more interesting.

The Why — The 8 Arrangements of Design

The way we lay out the marks on the paper

Now that we know the seven marks (tools) we can put on the rectangle of paper, how do we place them? We use 8 ARRANGEMENTS — the why of design.

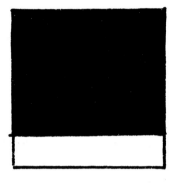

1. UNITY

Unity is the single most important principle. It means that your painting has a "oneness". It must have something that dominates and relates all the parts to each other. It might be a dominant color. It might be a repeating shape or direction or several of these. If part of a painting is noticeably different, then unity is destroyed. For example, a Beethoven sonata with a few bars of "heavy metal" music thrown in would have no unity.

2. CONTRAST

Contrast is the juxtaposition of opposing forces. It can be subtle or violent. Contrast can be evident with any of the tools. Contrast gives a painting vitality and sparkle. Without contrast the painting would be flat and boring.

The strongest contrasts can be used to attract the eye to the center of interest. However, strong contrasts should not appear near the edges of the picture.

Too much contrast overpowers the senses and causes confusion. Contrast can be tempered by using the arrangement of dominance to restore unity. See page 24.

3. DOMINANCE

Dominance is the superiority of one tool over its siblings. Dominance of any one or more of the tools will achieve unity. It may be an overall color influence or the repetition of a shape or a dominant tonal value. There are many ways to impose dominance.

"We only need to work with seven TOOLS (the marks we place on the paper) and eight ARRANGEMENTS (the way we place those marks on the paper). That's all."

4. REPETITION

If you repeat any of the seven tools you will establish dominance and unity.

5. ALTERNATION

This is where two tools alternate to set up a rhythm. Vary the intervals to avoid monotomy.

6. HARMONY

Harmony differs from repetition in that the repeats are similar, not the same. Adjacent colors on the color wheel, such as blue and green or red and orange, are harmonious because of their close relationship to one another.

Harmony may be present in all the elements of design.

7. GRADATION

Gradation is the gradual change from one extreme towards the other. It can be applied to any of the seven tools. It can stretch all the way across a painting or just to one area. Because the changes are gradual, the effect is always harmonious.

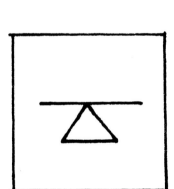

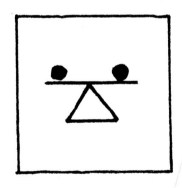

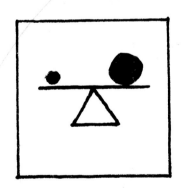

8. BALANCE

Balance is a perception of equilibrium, a feeling that it looks right. It's difficult to measure precisely but a few guidelines will help. Balance is assessed from the vertical center line outwards in both directions.

FORMAL BALANCE

A symmetrical arrangement is called formal balance. A single object placed on the center line, or two identical objects placed one each side of the center and equidistant from it, would be formal balance.

INFORMAL BALANCE

Asymmetrical, or informal, balance is most often used by the watercolorist. Informal balance is when a dominant object is balanced against a lesser one. The best arrangement is to place the dominant shape near the center and the minor one further out. This can be likened to the leverage principle with two uneven weights placed on a see-saw. The heavier one must be nearer the pivot point in order to maintain balance.

Informal balance is more dynamic and interesting. Ultimately your intuition will guide you as to the best placement.

HOW CONTRAST IS SUBDUED BY DOMINANCE TO CREATE UNITY

CONTRAST OF LINE
Thin curved vs. Straight thick

Thin curved dominant

SHAPE
Round vs. Square

Round shapes dominant

TONAL VALUE
Light vs. Dark

Light tone dominant

SIZE
Small vs. Large

Small size dominant

COLOR
Warm vs. Cool

Warm color dominant

TEXTURE
Coarse vs Fine

Fine texture dominant

DIRECTION
Vertical vs. Horizontal

Vertical direction dominant

The 8 Arragements of Design in Action

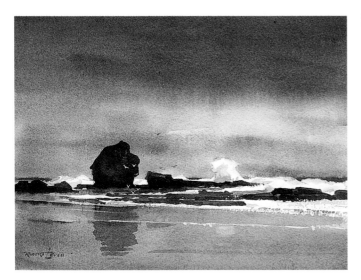

THE MAIN ARRANGEMENT USED HERE
UNITY
'CURRUMBIN ROCK'

Just a few minutes from my studio is Currumbin Beach, one of my favorite subjects. I have painted this rock in many different moods and with different interpretations. It is a good idea to render a familiar subject in different ways. This time driving rain and rough seas gave me the opportunity to use a unifying range of colors. This very simple painting exhibits most of the design arrangements.

UNITY
Unity is achieved through dominance of the mid tone, the cool gray color scheme and the horizontal direction. Notice the dominant size of that powerful, dark rock.

CONTRAST
The strongest contrast is at the center of interest — the white of the foam against the dark of the rock.

REPETITION AND ALTERNATION
These arrangements are manifest in the horizontals. The whole painting is in harmony by way of the simple color scheme.

BALANCE
The design is nicely balanced, with the large mass of the rock set off-center and counterbalanced by the horizontal thrust of dark rock extending to the extreme right margin. This is given more emphasis because it is sandwiched between two bands of white (ALTERNATION).

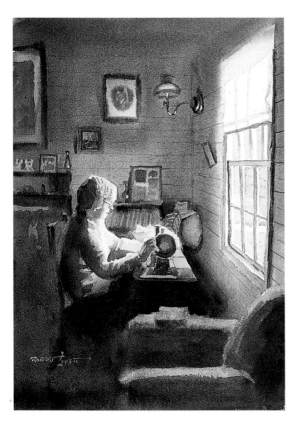

THE MAIN ARRANGEMENT USED HERE
CONTRAST
'ROSE SEWING'

CONTRAST
The main feature is contrast in tonal value. The strong contrast of the light is dominated by the vast area of darks, thereby retaining unity.

HARMONY
There is harmony of color, with cool colors dominant.

GRADATION
Cool blue at the top changes towards violet at the bottom.

DESIGN PLAN
Rose lives alone in a little cottage tucked away in the Snowy Mountains. There is no electricity so she pedals away at her old Singer sewing machine. The painting demonstrates the principle of CONTRAST.

The painting was executed with many wet-into-wet passages. Dry, crisp edges were reserved for the center of interest, the figure and the window.

The 8 Arragements of Design in Action

THE MAIN ARRANGEMENT USED HERE
DOMINANCE
'THE FLOATING MARKET'

DOMINANCE

The dominance of the oblique direction and repetition of shapes ensures unity in this watercolor.

CONTRAST

Contrast of direction is seen in the vertical poles, especially the two in silhouette at top center. Tonally speaking, it is the mid-tone that dominates. See how the whites are scattered across the middle of the picture, and are repeated in that small area of light at the top. Note the position of the shadow across the top which allows the large mid-tone area to dominate. That small area at the top comprising mid and light tones, isolated by the shadow, creates a wonderful contrast in size.

The most conspicuous aspect of the painting is the powerful diagonal thrust of the boats. The shadow plays an important role here because it stops the eye traveling out of the picture.

DESIGN PLAN

The floating market near Bangkok bustles with activity in the morning when the local people bring their produce for sale in their flat bottom boats, which are the main means of transport on the extensive canal network.

This was an opportunistic subject requiring very little rearrangement. When you understand the design principles you will be able to seize opportunities like this.

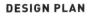

THE MAIN ARRANGEMENT USED HERE
DOMINANCE OF COLOR
'VENICE'

This painting achieves unity through DOMINANCE of color. The red pervades the entire picture.
The center of interest is the bridge and gondola, but see how the bridge connects the two large masses of dark red, creating a visual pathway. This was a fortunate feature of the subject, but there is no reason why you cannot change colors to achieve this.

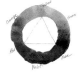

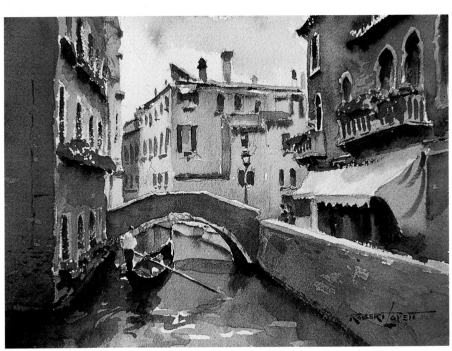

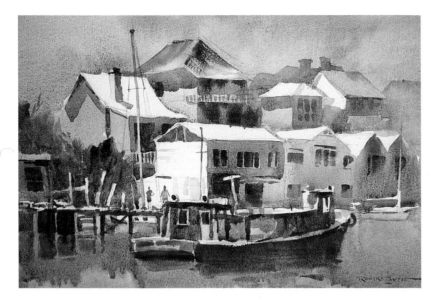

THE MAIN ARRANGEMENT USED HERE
REPETITION
'BIRCHGROVE WATERFRONT'

The dominant feature is the REPETITION of the white geometric shapes of the buildings. The white areas vary in shape to prevent monotony. Contrast is provided by the dark boat hulls and the soft shape of the trees.

THE MAIN ARRANGEMENT USED HERE
ALTERNATION
'ARCHES OF CORFU'

DESIGN PLAN

The repeating concentric semi-circles of the arches, graduating in size and alternating light and dark, set up a rhythm and create a powerful focusing effect. The eye is immediately drawn to the distant and mid-distant figures.

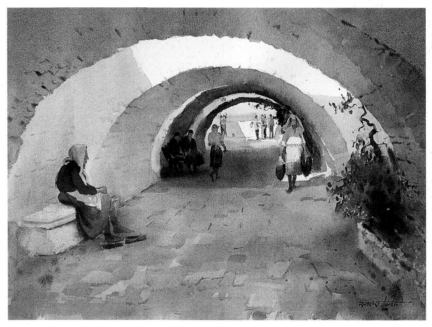

THE MAIN ARRANGEMENT USED HERE
ALTERNATION
'BOGANGAR'

Alternating horizontal bands of light and dark create the rhythm in this painting. Horizontal banding such as this often appears in landscapes. Recognize it and incorporate it into your designs

Notice how the shape of the headland is repeated time and again in the rocks.

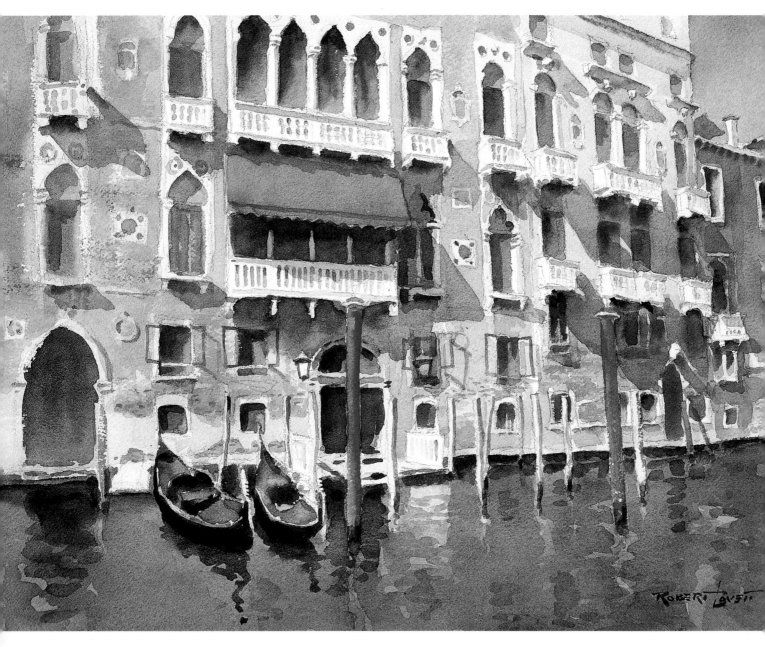

THE MAIN ARRANGEMENT USED HERE
ALTERNATION
'VENETIAN FACADE'

You can feel the rhythm flowing across this facade as the windows alternate on the weathered building.

The dark area of the water provides contrast but allows the lighter area of the wall to dominate. The two sections are joined together by the intervening poles, gondolas and dark doorways.

THE MAIN ARRANGEMENT USED HERE
HARMONY
'THE COLOSSEUM'

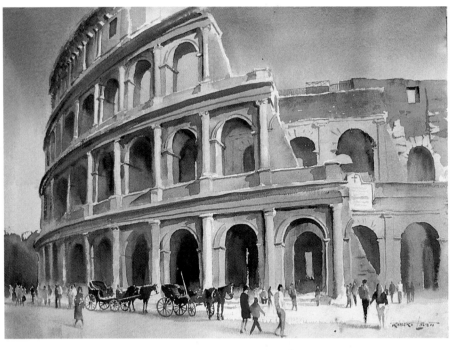

HARMONY
What a superb example of architecture dating from 72 AD. The architecture itself is in perfect HARMONY. See the subtle variation of the arches and columns from one level to the next.

GRADATION
The perspective enhances variation as the archways reduce in size from right to left. This is a perfect example of GRADATION. The curves also exhibit beautiful harmony and gradation.

Gradation of tone can be seen on the building, changing from dark on the left to light to the right.

REPETITION AND ALTERNATION
Look at the wonderful REPETITION and ALTERNATION. The vandals who pillaged the marble from the Colosseum to build St. Peters unwittingly helped to make this picture a success. The facade is broken down to reveal the inner wall, causing a change in rhythm, and preventing monotony. Notice how the two segments are unequal in size, enhancing dominance.

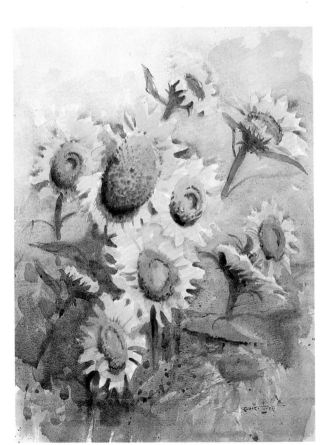

THE MAIN ARRANGEMENT USED HERE
HARMONY
'SUNFLOWERS'

The harmony here is twofold:

COLOR
The dominant yellow is closely related to the orange and the green, since they are adjacent on the color wheel. The background is warm and in HARMONY.

REPETITION
The REPETITION of shapes is another unifying factor. Notice the variation in size, shape and spacing of the flowers. There is an interesting gradation in tone from light at the top to dark at the bottom. This gives stability to the design

The 8 Arrangements of Design in Action

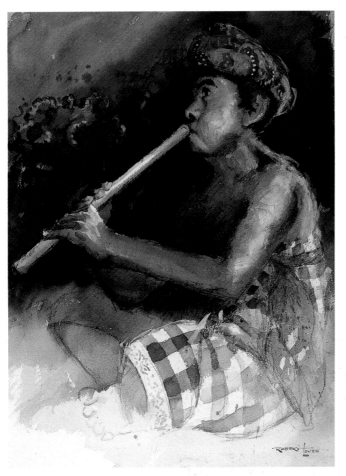

THE MAIN ARRANGEMENT USED HERE
GRADATION
'THE FLUTE PLAYER'

The powerful GRADATION across the entire picture plane draws attention to the dark area at the top and the main features of the subject. Because of the gradation, the whole picture area is more interesting. The eye has easy passage into the bottom of the painting and follows a visual pathway up the arms and flute to the head.

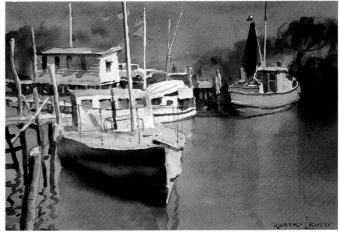

THE MAIN ARRANGEMENT USED HERE
BALANCE
'FISHING BOATS, YEPOON'

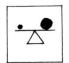

This painting demonstrates INFORMAL BALANCE. The boats and sheds mass together to form a high contrast point of interest, just to the left of center. See how this is balanced by the single boat out to the right.

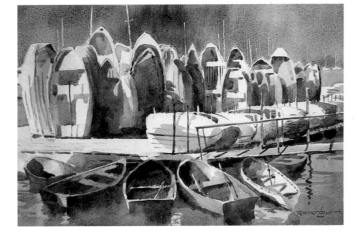

REPETITION IN ACTION

This painting demonstrates the principle of REPETITION. The repeats are not always so obvious in paintings. Be on the lookout for any repeating elements you can incorporate into your design.

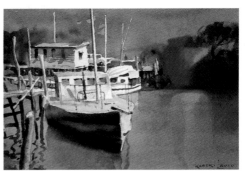

THIS VERSION IS OUT OF BALANCE

Here's how the painting would look without the boat to balance it. See how lopsided it appears. You get an uncomfortable feeling that the whole thing will tip over to the left.

But not all at once, please!

I have just presented a huge amount of information that could be completely new to you. This is exciting but terrifying at the same time because now, instead of just daubing away and hoping when you begin a painting, there are 15 important things that have been brought into your awareness. That's a lot for anyone to think about at once.

If you examine the example paintings in this chapter you will see that each of them has a main tool or a main arrangement. There's a big clue in there for how you could approach this new information. The way to practice your skills is to focus on one of the arrangements at a time, say repetition, and look for a subject that gives you the opportunity to practice that. Then look at the list of tools and decide how you can back up the theme of repetition, Maybe you could be repetitious with line, direction or shape. Once you have done that project successfully a few times, work your way through all the arrangements, using the different tools to support your ideas.

The important thing to remember is that even the best paintings in the world do not contain all the tools and all the arrangements in one hit. Strength in one or two areas will lift your paintings to a new level — where your conscious design has an unconscious appeal to everyone who views it.

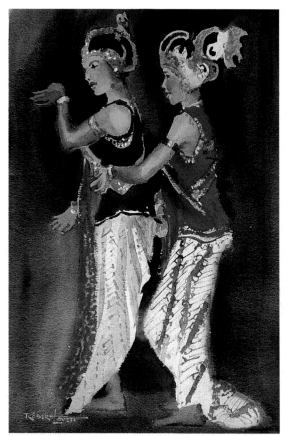

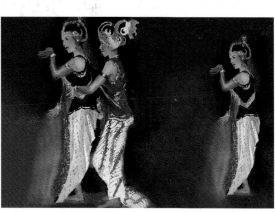

THE MAIN ARRANGEMENT USED HERE
FORMAL BALANCE
'RAMAYANA DANCERS'

This is one of the very few paintings where I have used FORMAL BALANCE.

Vertical format was used here because it suited the subject. The dancing was rather sedate, slow and formal. I felt satisfied with this result.

HOW WOULD IT WORK IN A HORIZONTAL FORMAT AND WITH INFORMAL BALANCE?
One of the figures has been cloned and danced to the other side of the picture.

My feeling is that the original solution above is better. The focus here is more divided than it was in the upright version

What do you think?

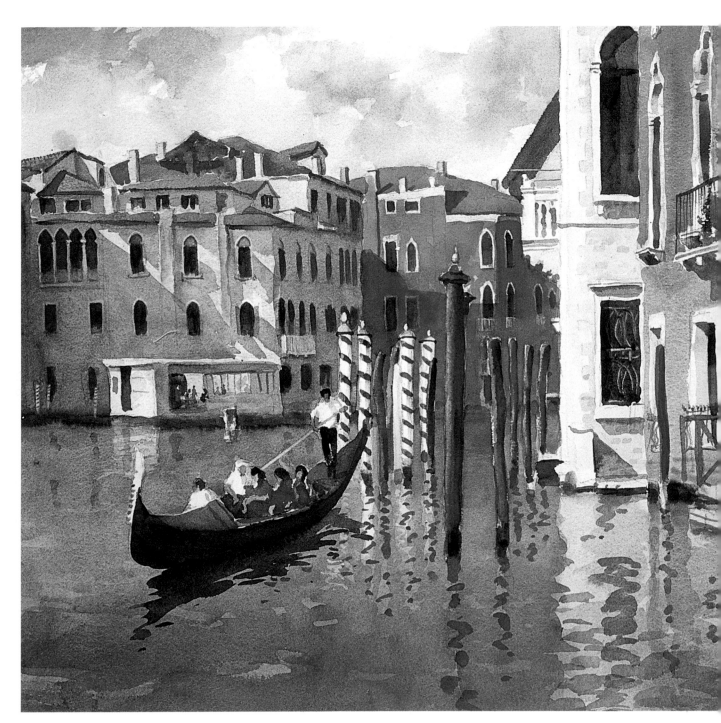

'BLUE POLES, VENICE'

Part 3
Training yourself
to plan your painting

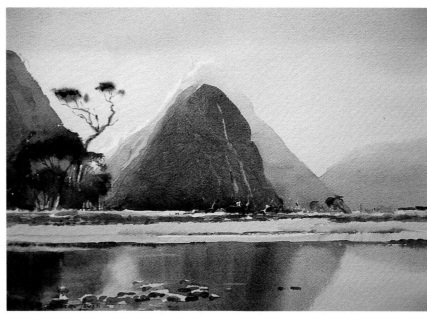

'MILFORD SOUND, NEW ZEALAND'

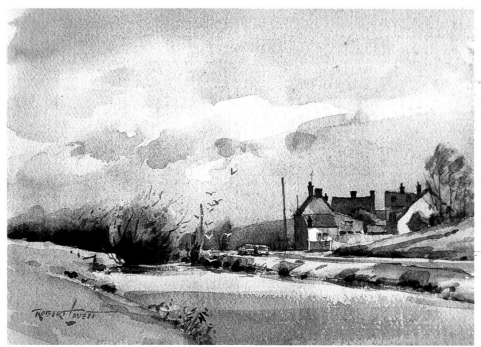

'NORFOLK WATERWAY, UK'

Seizing the essence of your subject with

Some tips for going out into the world with your sketchbook and camera to capture the essence of your subject.

By now you should have an understanding of the **how** and **why** of design — the tools (marks) and their arrangement (layout) on the paper. From this time forward, when you go looking for subjects to paint you should be starting to see in a different way. Instead of seeing rivers, mountains, trees, houses, boats, people, and so on, you will begin to see in terms of **lines**, **tonal values**, **colors**, **shapes**, **directions**, **textures** and **contrasts**. You will see how all these relate to one another through **unity**, **contrast**, **dominance**, **repetition**, **alternation**, **harmony**, **gradation** and **balance**.

In other words, you will begin to see in the abstract, even though your paintings may be representational.

Choosing subjects is personal

Your search for subjects is very personal. It bears an emotional content, which is different for everyone. Subject selection is influenced by your likes and dislikes, past experiences and even to some extent by your gender. Generally, women perceive the world differently from men, and this is manifest in their paintings. The fact that everyone is different provides us with an incredible variety of interpretational styles in our art. You will be drawn to certain types of subjects that you will interpret in your own way. In doing so, you will come to know yourself a little more.

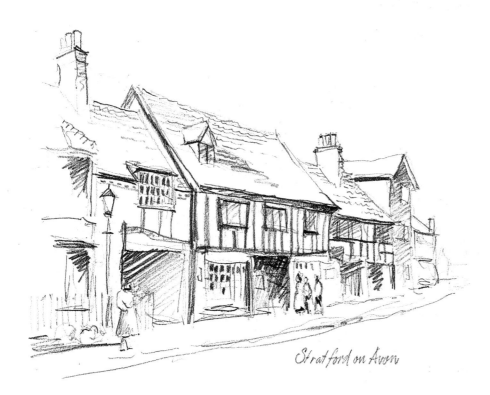

Stratford on Avon

'STRATFORD ON AVON', PENCIL

sketches

Choosing the best light

My early years were mainly dedicated to landscape. It took years of trial and error to discover the simple fact that the best light on the landscape is in the early morning and late afternoon. I wasted days driving around in the middle of the day searching in vain for "the perfect subject", only to come home empty-handed and frustrated. I should have been venturing out into the lovely, late afternoon light. Or I could have been seeing the possibilities in the very early morning, which is a truly magical time of day, when the light transforms the ordinary into the spectacular. In particular, frosty morning light casts a special magic and you are well rewarded for leaving your warm bed to go out in the cold.

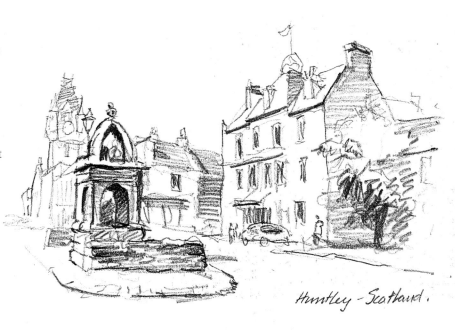

'HUNTLEY — SCOTLAND', PENCIL

Choosing to draw

I also spent many of my early years not owning a camera. In retrospect I am pleased because, instead of using a camera to capture the scene, I had the opportunity to rely on my sketches and to paint a great deal on location. I filled dozens of sketchbooks. Working this way sharpened my observation and imagination but, above all, I learned to draw very well indeed. I still carry a sketchbook everywhere I go and draw at every opportunity. When I travel these days I carry my camera, my sketchbook and a compact watercolour kit. I come home with many photographs, a

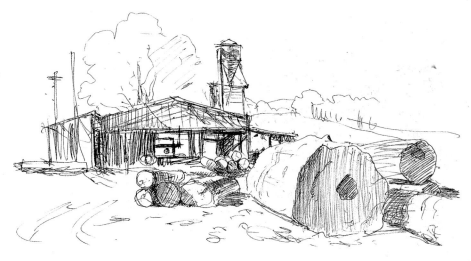

'SAWMILL', BALLPOINT PEN

LEARN TO DRAW!

Such a directive may seem unnecessary. Yet I find so many students who "just want to paint" and skip what they consider to be the tedious business of learning to draw. There are others who believe they can draw but they do not understand the fundamentals of proportion, structure and perspective. Do not delude yourself. Be honest. If you have any difficulty with drawing, learning the basics is time well spent. You cannot "get away with it". Drawing is the very basis of all painting. Watercolor is drawing with a brush.

book full of sketches and a number of completed watercolors.

I strongly urge you to always carry a sketchbook and to draw, draw and draw. Your camera is very convenient for recording information but you are missing an important aspect of your work if you do not draw from nature. You cannot do this through the lens of a camera.

Choosing total recall

One day I was traveling by bus and didn't have a camera or sketchbook with me when a terrific subject, lit by wonderful light, appeared and passed by in a matter of a few seconds. I observed it as intensely as I could while

it lasted, then closed my eyes to allow it to seep into my subconscious. When I arrived home, I put the scene down with watercolor to the best of my memory. I was amazed at the amount of information I had absorbed and recalled simply through observation and concentration.

Old dray
"Spring Range."

'OLD DRAY, SPRING RANGE', PENCIL

'OLD COTTAGE', BALLPOINT PEN

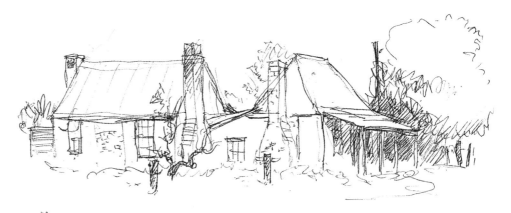

'MONT FIORES', BALLPOINT PEN MONT FIORES

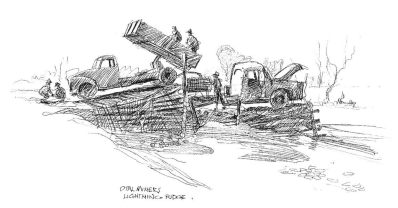

'OPAL MINERS, LIGHTNING RIDGE',
BALLPOINT PEN

'THATCHED COTTAGES, SUSSEX', PENCIL

Painting on Location

One of my greatest pleasures is to camp out in the Australian Outback and to be right there on site as the sun rises. Nothing stirs the soul so much as that magic light, the smell of eucalyptus and the smoke of the campfire. I have had many such wonderful experiences, often shared with fellow artists. We would paint during the day and compare and critique our work around the campfire at night, with a couple of drinks and some lively conversation.

Painting on location requires the utmost concentration. The distractions are many, and you must be keenly aware of the changing light on the subject. You must work quickly. You must contend with the elements, wind, bright sunlight, flies and curious onlookers. It is imperative that you simplify the subject. You are overburdened with detail. You must learn to see the subject as simple masses of tonal value. Your tonal sketch, even if

TOTAL RECALL EXERCISE

Try this. Observe a subject intently for a few minutes without sketching. Note the major proportions and tones and main features, as well as a few details. Close your eyes and let the image simmer. Then paint what you recall. I believe you will be surprised. You will have remembered the essentials and eliminated what was unnecessary. In other words, you were forced to simplify. That is what we must do, even when we have recorded the scene with sketch or photo.

"Really seeing your subject means seeing in the abstract."

very rough, is most important here. Although there is a hit-or-miss element, the watercolors I paint on location are often more spontaneous than my studio paintings.

I enjoyed many painting excursions with my artist friend, Leonard Long. He is blessed with infectious enthusiasm, nothing deters him and every expedition was a new and wondrous adventure. We have worked outdoors in the 40°C heat of the Australian summer. We have stood knee deep in the snow to paint in the Snowy Mountains. We always became so immersed in our work that we failed to notice the physical discomforts. Only once I recall quitting because of a blizzard in the mountains. It was so bitterly cold I could not hold a brush.

You might ask, "Why go to all the trouble?" The reason is because there is something special about being there.

I must confess that I have mellowed in recent years. I am not so adventurous and have discovered that I like my comforts. I still enjoy painting on location but the conditions must be favorable.

For instance, it was in St. Abbs, Scotland that I met a hardy Scottish artist who was very friendly and hospitable. He suggested that we go out painting. A howling gale was blowing right off the North Pole that day. I politely declined, saying something about painting for pleasure, not punishment. "It's OK" he replied, "I'll loan you a jacket". It was hard to convince him that I'm not of the same tough stuff as the Scottish.

Painting on location is not without danger. One day while out painting with my artist friend Jack Kirkland we found a great subject by a bend in the road. I sat just off the roadside, with my back resting comfortably against a solid post, and began to paint. It wasn't long before I began to feel uneasy as a few cars hurtled around the bend, with tyres squealing. I decided to move. I picked up my gear and clambered down the embankment. Just as I was getting through the fence another car screamed around the bend, out of control. It hit the post in the exact place I had just been sitting, then it flipped over and finished upside-down against the fence, just a metre from me. The driver was scratched and shaken but otherwise unhurt. Needless to say, Jack and I abandoned that location and moved on. We found an old slab barn (well away from the road). We sat with our backs to the barn and began to paint the rural scene. It was quiet and Jack remarked how peaceful it was after our earlier experience. Then, without warning, there was a loud BOOM! and shotgun pellets showered down all around us, clattering on the iron roof. We got out of there so fast we didn't stop to find the source of the shooting. That day we came home empty handed, but glad to be alive.

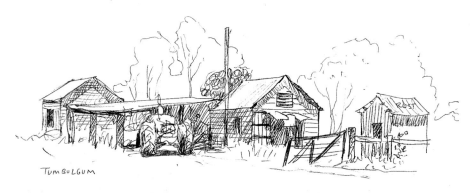

'TUMBULGUM', BALLPOINT PEN

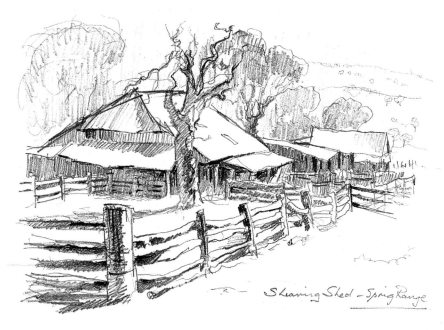

'SHEARING SHED, SPRING RANGE', PENCIL

Seizing the essence of your subject with sketches

Direct drawing with a watercolor brush

Try drawing direct in watercolor with no preliminary pencil work. Do small still life subjects, household objects and your pets. The cat was drawn directly with the brush as she napped. Sketches like this are fun to do and are very good training discipline.

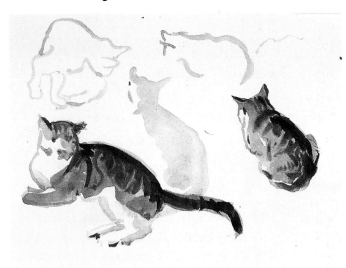

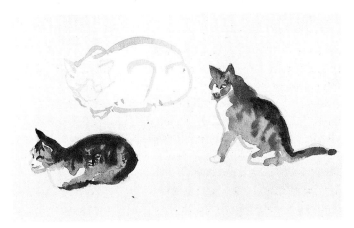

OPPORTUNISTIC DIRECT WATERCOLOR DRAWINGS OF MY CAT

Direct drawing with a fountain pen

The cellist and bass player were drawn directly with a fountain pen at a chamber music concert. This is great practice and makes you work quickly.

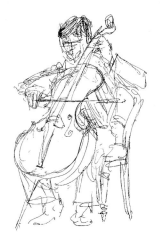

It doesn't matter where you are, you can practice your drawing skills.

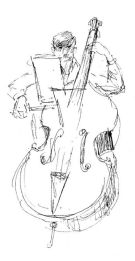

SKETCHING

- The pencil sketches in this chapter were all done quickly with a 2B pencil. Some accents were added with a 5B pencil. Graphite pencil is one of the most satisfying of sketching mediums. It produces a lovely range of grays and black, allowing you to very quickly establish the tonal values. A couple of pencils and a small pad in your pocket is all you need. What better way to explore and analyze your subject.

- Even more convenient is the black ballpoint pen — I use one frequently for sketching. It is always at hand. Establishing shadows and tones is more difficult but the results are beautiful. You can see the simplicity of the ballpoint pen sketches shown in this chapter. They are adequate reference for a final painting.

- Try different mediums. There are many good reservoir-type fountain pens for drawing. These produce a varied thickness line giving more character to your work.

- A miniature watercolor box with about six colors and two brushes is all you need to make little watercolor sketches on a small pad. The secret is to make the washes simple.

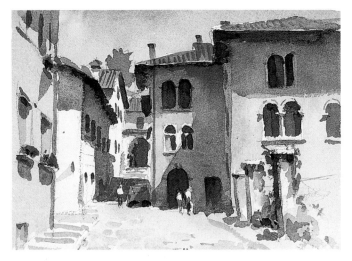

STUDY THE DIRECTION OF THE LIGHT

When you sketch your subject, make certain you maintain a constant light direction. This will make painting shadows and creating reflected light very much easier, and the end result will be authentic and coherent.

EXERCISE

What mood do you think I was trying to create here?

In terms of design, what do you notice about this scene?

Notice the treatment of the shadow that links the entire painting together, giving unity. Try this on your next painting.

STUDY THE VIEWPOINT

Vary your designs so that not every scene is presented to the viewer at your eye level. You can either have viewpoints that are low, like this, which serve to emphasize the structure and status of buildings, or elevated, which give a grander scale and serve to emphasize the distance.

EXERCISE

On your next sketching trip make high, low and middle viewpoint sketches of the same subject to see the difference these make to the scene. Choose the one you prefer. Then ask yourself what it is about that one that appeals to you. You will then have another major design strategy at your disposal.

USING YOUR CAMERA

Most artists I know use a camera to gather information. It is certainly a wonderful tool, especially when you are traveling through beautiful locations in different countries, and your time is limited.

It is best to take your own photographs. Your individuality begins right here. Your choice of subject, point of view and composition are all your own design decisions made right on the spot. Bringing home a bunch of photographs can be very exciting but, beware, there are traps. Rarely do you get a ready-made subject.

Mother Nature is great, but she hasn't read my chapter on Design. It is still up to you to organize the image according to the design principles.

Another danger is to just copy the photograph. A photograph usually contains too much detail so you must simplify and eliminate. As well, film cannot cope with a broad spectrum of light intensity, so that photos in bright sunshine with high contrast are often deficient at one end of the range. You will find that if the sunlit areas are correct the shadows will be dense and without detail.

Then, if the shadows are transparent, the lights will be washed out. The human eye with its quick adjustments of the iris can cope with this range of light conditions, but even at one-thousandth-of-a-second, the camera cannot. In such contrasty conditions, I normally take two shots at different exposures to cover both shadow and light.

Always remember to CREATE your picture. Use your imagination and knowledge to eliminate, simplify and organize your subject according to the design principles.

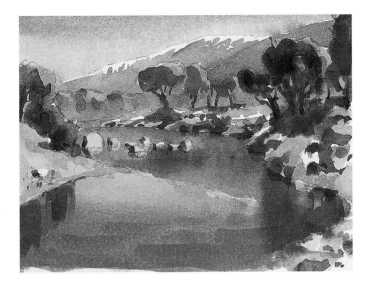

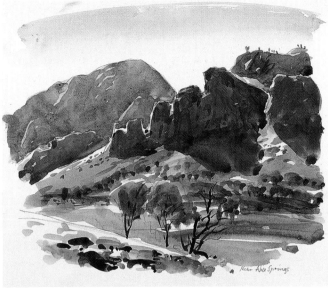

STUDY THE LACK OF DETAIL
Notice how there is no detail, but plenty of information in this little sketch. The light direction, reflections and tonal value plan have already been established.

STUDY THE SHAPES
This quick sketch made near Alice Springs in Australia's Red Center captures the spirit of the place in a more emotive way than would have been obtained by photograph. The direction of light and tonal plan established in this sketch will help immeasurably when it comes time to make a major painting of this scene back in the studio.

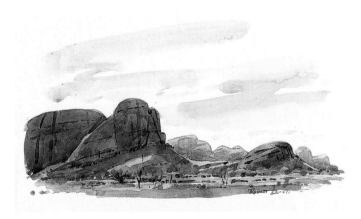

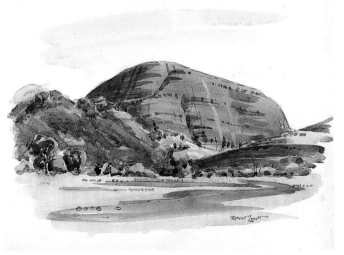

STUDY THE SCALE
Size plays an important role in capturing immense, ancient landforms like we have in Australia. Scale has been suggested by the small dotted bands representing the trees. Even the loose, upward sweep of the watercolor "swoosh" indicating the clouds helps. I now have an idea how I can use cloud formations to give an even greater sense of scale when I tackle the major painting.

STUDY THE COLOR AND TONE
Because the tones are close in value I made sure there was some warm/cool colour contrast happening. There are lots more ideas for the major painting in this little sketch.

Planning the picture

Preliminary planning means you get a pretty good idea of how you want the finished painting to look. That means you know what you have to do to achieve it.

A great deal of planning goes into making a watercolor painting. Site sketches, tonal value sketches and color notes all give you a clear idea of what you want to achieve. They are vital to the painting's success. Naturally, you will also need to think how to use the tools and arrangements of design to best effect.

To raise your awareness of design, make it your habit to consider the tonal value arrangement of a painting before you begin. Then, every time you finish a painting, look at it again and assess it in terms of its tonal values and design elements. If you keep doing this, very soon you will be able to spot those relationships you made instinctively, and those relationships that could have been improved with a little bit of forward thinking.

One of the pitfalls of location painting is just copying what you see. Instead, train yourself to design and compose to eliminate and simplify.

Understate. I know this is not easy when you are confronted by changing light and there is only a limited time in which to work, but you can do it. It will help if you have some idea of the sequence of washes, where you intend working wet-into-wet and where you will place those crisp edges. Work

THE 6 BASIC ARRANGEMENTS OF LIGHT, MID-TONE AND DARK TONAL VALUES

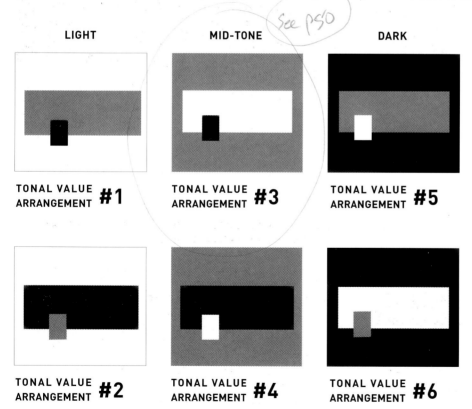

LIGHT MID-TONE DARK

See p50

TONAL VALUE ARRANGEMENT #1

TONAL VALUE ARRANGEMENT #3

TONAL VALUE ARRANGEMENT #5

TONAL VALUE ARRANGEMENT #2

TONAL VALUE ARRANGEMENT #4

TONAL VALUE ARRANGEMENT #6

Look closely at the 6 diagrams here:
- In the LEFT column a **LIGHT BACKGROUND** dominates
- In the MIDDLE column a **MID-TONE BACKGROUND** dominates
- In the RIGHT column a **DARK BACKGROUND** dominates

When planning your arrangement of Tonal Values, I recommend you try one of those shown here.

There should be a very definite dominant tone, and of the remaining two, one must dominate the other. Ideally, this would mean you finish up with one area of tone which is very large, one area very much smaller and a third one very much smaller again.

The possibilities are infinite. Most paintings fall into one of these categories. This is not a hard-and-fast rule, merely a guide.

quickly, but bear in mind the final effect you are aiming for. Don't just gamble and hope. Plan for a good result.

Planning the picture

When you have your information, sketches, photographs or even your memory from observation, you must make a plan. Your result is not a matter of luck. You cannot work it out as you go along. You must have a plan. This is where your imagination comes into play.

Ask all kinds of questions. Ask yourself what the most important design features are, then ask how you can emphasize these. Use a checklist of "what ifs". For example:

- What if I Increase contrast, decrease contrast, exaggerate color, simplify color, choose a dominant color, change the tonal key, simplify the foreground, add a figure or crop the image?

Make a tonal value plan

The next step is the tonal value arrangement. This can be done in the form of a thumbnail sketch made with a soft pencil or it could be done with a monochrome wash. Although the tonal value range is infinitely variable from black to white, we will divide it into three parts "light", "mid-tone", and "dark". This is an over simplification but it will be easier to understand if you

There are many more possibilities. Make your own checklist. You will be surprised how asking questions like these will improve your creativity.

study the 6 basic diagrams opposite. So, when you next do a tonal sketch ask:

- What is the dominant tonal value, dark (low key), mid-tone or light (high key)?
- What are the areas of greatest contrast? (They should be your focal point.)
- Can I link areas of similar tonal value?

ORIGINAL SCENE AT BLUE COW, AUSTRALIA

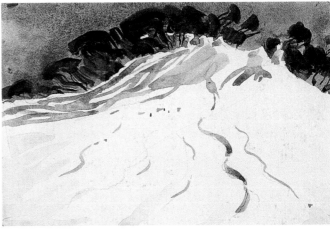

TONAL ARRANGEMENT #1 — THIS IS A HIGH KEY SUBJECT IN WHICH THE WHITES DOMINATE

In the original scene, the white dominates. The mid-tone (sky) is smaller and the dark (trees) smaller again.

"White" is a term used loosely in this three tone arrangement. It actually consists of many subtle shades of light gray.

When I made the tonal sketch, I moved the ripple in the snow to the right (away from the center). It makes a perfect lead in. I kept the sky area as small as I could to allow the whites to really dominate.

Notice the wonderful rhythmic patterns of the tree shadows

and the tree trunks. You must take advantage of things like this and emphasize these rhythms in your painting.

There was not much to rearrange in this picture because composition began when I made the photograph. As your knowledge of design improves you will look for rhythms and patterns, and will more readily recognize subjects you may have previously passed by.

The photograph is an example of high contrast. Because the camera sets the exposure to accommodate the brilliance of sunlit snow, the trees and sky became dark. However, in this case it could be treated that way in the painting to achieve a pleasing contrast.

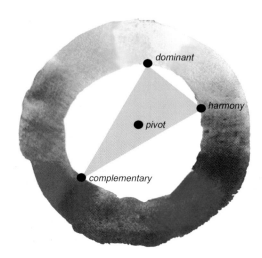

MAKE A COLOR PLAN

✓ It is a good idea to have a color plan as well. If not on paper at least in your mind. Ask yourself these questions:

- What will be the dominant color?
- Where can I place a small patch of complementary color?
- Which other colors should I use in harmony with the dominant color?
- How few colors do I need to make this statement?

Beginners can become inhibited by too many color theories so I believe it is best to keep color very simple at the start. As you advance, more sophisticated color arrangements can be used.

A SIMPLE WAY TO SELECT A HARMONIOUS COLOR SCHEME

Select two colors next to or close to each other on the color wheel. One of these should dominate.

Select one color opposite on the color wheel. This is the complementary and should be used sparingly.

The diagram shows how this works. You could make one from card so that the triangle will rotate on the pivot. You can vary the distance between the dominant and the harmonious color, but not to the extent that it becomes an equilateral triangle — keep them reasonably close together. Of course you can reverse the position of these two.

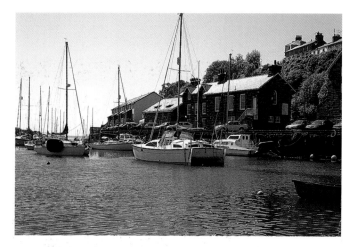

ORIGINAL SCENE AT PORTHMADOG, WALES

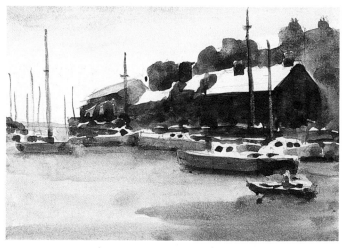

TONAL ARRANGEMENT #4 — THE MOST COMMON TONAL PLAN WITH DOMINANT MID-TONE, SMALLER DARK AREAS AND VERY SMALL WHITES

See how the whites stand out in contrast to the surrounding darks. Because this subject is backlit, the dark tones are massed together and treated as one with subtle variations throughout. I am always disappointed to see modern fiberglass craft and not the old wooden boats, although It makes little difference in this subject because the boats are not detailed and just become a part of the tonal

mass. See how I moved the large catamaran to the right to improve the balance. The addition of the little rowboat or runabout in the right foreground also helps the balance and enhances the perception of depth. The composition is very simple, with a large wedge of dark thrusting out from the right balanced by the small dark shoreline on the left.

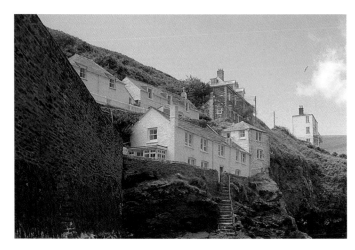

ORIGINAL SCENE AT PORT ISAAC, CORNWALL

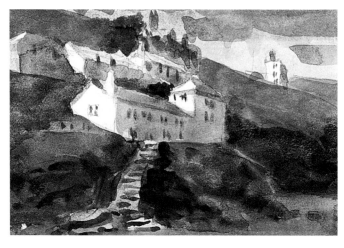

TONAL ARRANGEMENT #5 — ADOPTING A LOW KEY ARRANGEMENT SERVES TO DRAMATIZE THE SUBJECT.

This sketch has dominant darks with lesser mid-tones and small white areas. You see how it's possible to force the lighting to create this dramatic effect. The white sunlit area of the houses creates a strong focal point, so I positioned the darkest dark nearby. The stairs create an inviting lead in. The distant house repeats the geometric shapes and tones of the major buildings and creates balance.

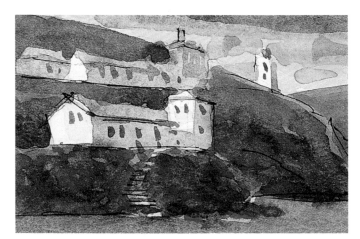

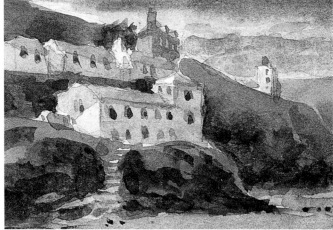

USE COLOR SKETCHES TO HELP YOU CHANGE THE MOOD OF THE SCENE
Although the subject is gray and dark these two color sketches show how mood can be influenced by color.

Now plan your attack

You have your subject, you have devised tonal and color plans, now you need to plan the attack.

The beauty of watercolor lies in its freshness and spontaneous look. To preserve these qualities you need to decide on a sequence of actions that will bring about the desired result in the simplest and most straightforward way. Your approach will be influenced by the subject and by the effect you are trying to achieve. The picture plane is a flat piece of paper with various marks on it. The marks can be interpreted as decoration on a flat surface or they can suggest a three-dimensional space, giving depth and distance to the design. Either way the surface can have its own intrinsic beauty. The three-dimensional effect can be made very realistic or merely suggested. Somewhere in between these two extremes is my aim. I like to be able to read the subject with its space and depth but at the same time create a surface that is entertaining in itself.

CHOOSING PAPER

Your choice of paper will greatly influence the outcome of your painting. I strongly recommended that you experiment with different papers, not only to discover the ones you like best but also to familiarize yourself with the way certain papers lend themselves to the different effects you may wish to produce. Again I must emphasize practice. You learn by doing. Go ahead and try all of these techniques. You will most likely discover some of your own.

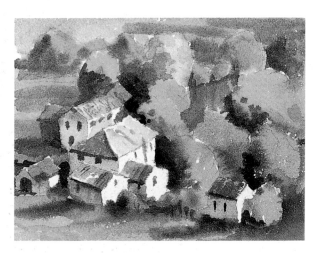

WET-INTO-WET ON HEAVY PAPER
This was painted wet-into-wet on heavy paper which was first soaked in water. Most of the washes were added while the paper was still very wet. As it dried, sharper edges were possible, even though the paper was still quite damp on completion. The general effect is of soft diffusion with a few sharp edges.

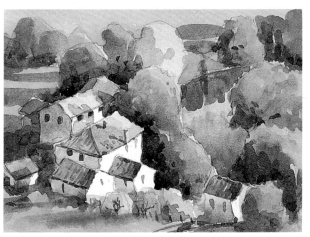

DIRECT ON SMOOTH HOT PRESS PAPER
This was painted direct onto hot press paper which is very smooth. You can see the difference. Here the edges are all sharp. There is not so much opportunity for blending. This paper is more difficult so handle but the effect is very suitable for certain subjects such as those with strong contrasts and high definition. It is also possible to paint with great detail on this type of paper.

WET-INTO-WET ON HEAVYWEIGHT PAPER — GLENROCK CROSSING

Wet-into-wet works best on the heavyweight, 300gsm or 600gsm, papers that can absorb lots of water. The paper can be soaked in a tub before you start painting, and it will remain wet for a long time. The washes become diffused as they are applied to the wet paper. As the paper dries out the washes become more crisp The final result can be a delightful dominance of soft with a few sharp accents to finish off.

This painting was done using this method. The landscape and the water are quite soft while the horses are sharply defined. As well as contrast in tone there is also contrast in edge treatment.

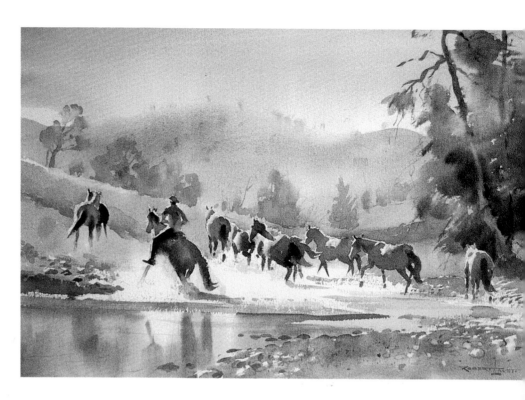

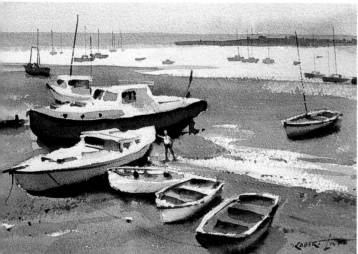

DRY BRUSH ON ROUGH PAPER — LOW TIDE, SUSSEX

Working directly onto dry rough paper that has not been prewet produces very ragged edge washes and brushstrokes that can be quite broken. This is achieved by holding the brush flat on its side and dragging quickly across the paper. The high spots on the rough texture pick up the pigment. If a preliminary wash is applied to the paper it becomes very difficult to achieve this dry brush effect. It is possible to produce smooth edged brushstrokes and washes by using lots of water. Here I painted directly onto the dry rough paper.

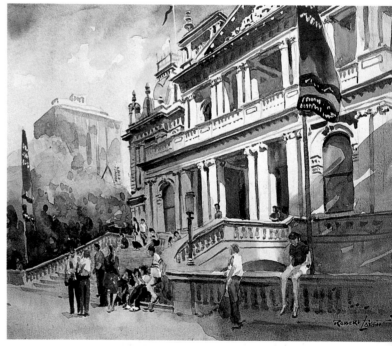

CRISP SHARP EDGED WASHES ON COLD PRESSED PAPER — SYDNEY TOWN HALL

Cold pressed is a most versatile paper. It has a slight texture which can make dry brush marks but is better suited to soft effect and also sharp edges. This is a perfect example of the effect you can get on cold pressed paper.

TONAL VALUE ARRANGEMENT # 1 — 'COCONUT MAN, INDONESIA'

- Dominant light
- Smaller mid-tone
- Very small black

A sharp edged treatment and leaving lots of white paper conveyed the brilliance of the light and the strong contrast. The darker background has a softer effect to enhance the crispness of the figure. The extended leg makes a good lead-in to the picture.
I sketched this man in the market place in Ambon, Indonesia.

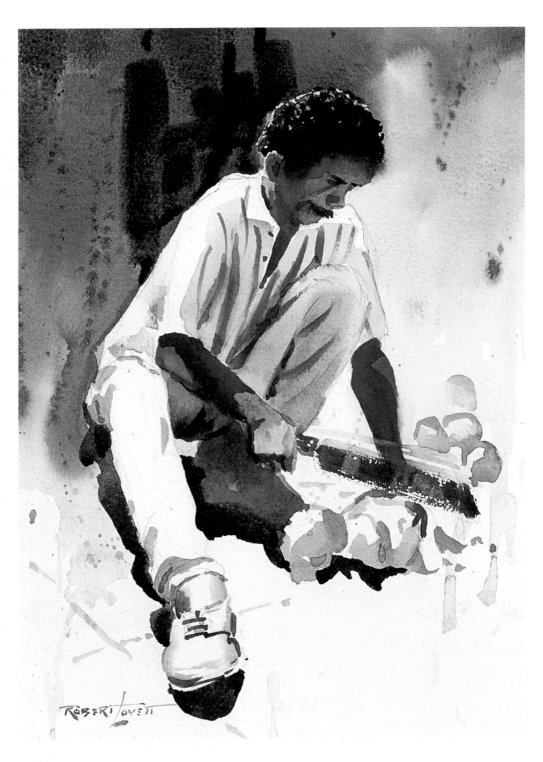

"I like to be able to read the subject, with its space and depth, but at the same time create a surface that is entertaining."

TONAL VALUE ARRANGEMENT #4 — 'THATCHED COTTAGE, ENGLAND'

- Dominant mid-tone

The strong white on the wall of the building is the center of interest. The nearby figure adds a little entertainment in this area. Note the repetition of the white geometric shape in the far building.

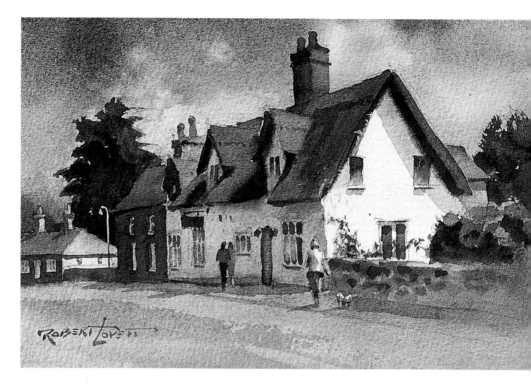

TONAL VALUE ARRANGEMENT #5 — 'BOAT HARBOR, AUSTRALIA'

- Dominant dark

This is a powerful painting. See how all the lights of the boats and buildings are clustered together in a horizontal band, with a small repeat up the hill. Notice the strong contrast in direction, with the vertical masts opposing the general horizontal thrust.

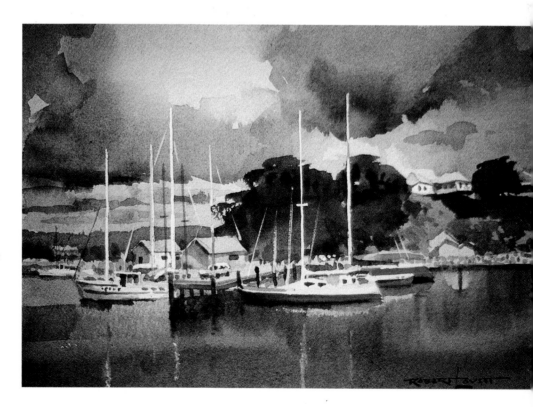

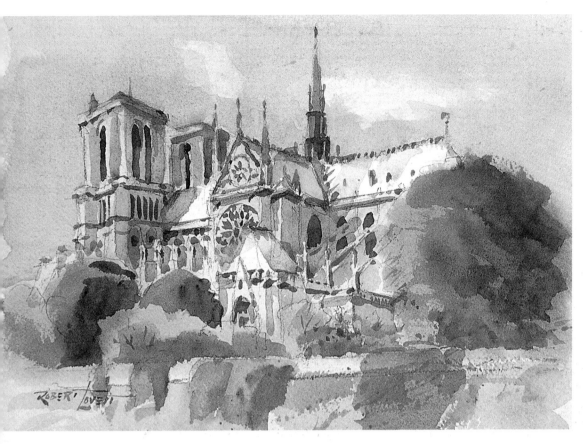

DOMINANT COLOR 'NOTRE DAME'

A quick little painting completed on location in Paris. It has a dominant yellow with some browns and greens in harmony. There is a hint of complementary violet in the shadows on the roof and in the upper sky. This is a limited tonal arrangement with dominant mid-tone and light and only the tiniest spots of dark. It works well here and gives a delicate feeling.

DOMINANT COLOR 'PIAZZA NAVONA, ROME'

Dominance of cool reds and pinks gives this painting a pleasing warm glow. Variety in color was introduced with the figures and awnings.

Again, the tonal range is dominant mid-tone, punctuated by all the little repeating darks of the figures and windows.

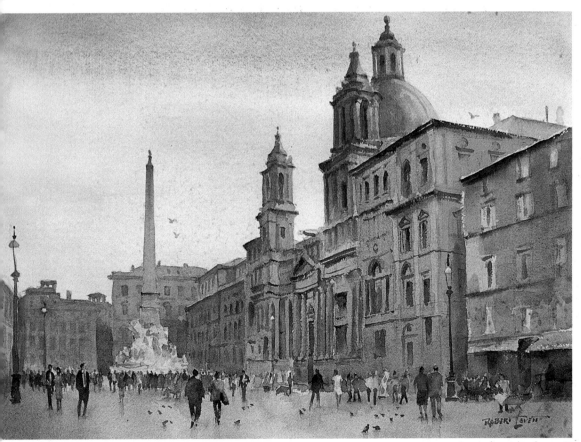

SETTING THE TONAL KEY WITH THE FIRST WASH

I used my preliminary tonal value sketch to work out my plan of attack. How simple is that!

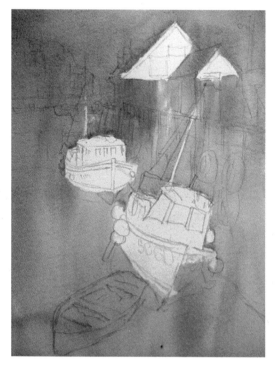

The first, big, mid-tone wash sets the key for the rest of the tonal values

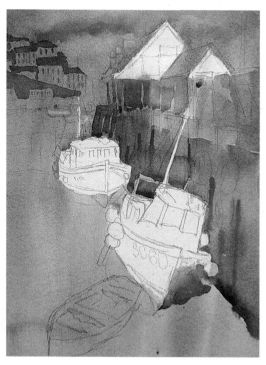

Contrast enhances the focal point, and the seaweed and wall reinforce the directional flow of the design

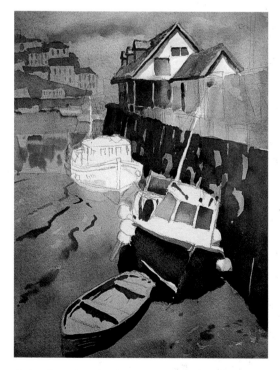

Color is not as important as tonal value — you can take a lot of latitude with color but the tones MUST BE RIGHT

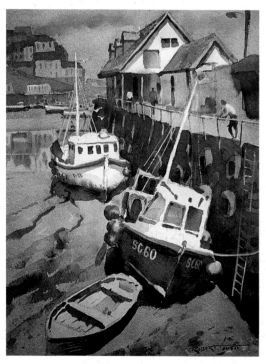

'LOW TIDE, CORNWALL'

Designing with perspective

It is essential for you to have a basic knowledge of perspective not only for visual accuracy, but because you can use those diminishing lines to good effect as part of your design.

Perspective plays an important part in everything we draw. This includes still life objects, boats, the human figure, animals, landscapes and particularly buildings.

I was fortunate during my early years to have worked in a large architectural office where I produced all the artist impressions of a great variety of projects. It was necessary for me to have an in-depth knowledge of perspective. Everything had to be accurately scaled and set out according to mathematical and geometric formulae. For the artist such knowledge is superfluous, but it has provided me with a sound basis and understanding for my paintings.

In major galleries throughout the world I see many highly regarded artists who get perspective wrong. I also see many students continually making mistakes in perspective. Yet it is so easy to learn a few basic principles that will get you by. You don't need a university degree, just spend a couple of hours learning the fundamentals and you will never make mistakes again. Accurate perspective is very important so here, without getting too deep, are a few basic principles.

How do I establish the vanishing point positions?

You must use your judgment together with accurate observation. In many cases the vanishing point will be way outside the boundaries of your drawing. It is not necessary to mark these points as long as you are aware of their approximate position.

What you must do first is to establish where your eye level is in relation to the scene. If you are by the seaside and can see the horizon then it is easy. The horizon is your eye level. Otherwise you must look for clues on the building, such as lines of brickwork or weatherboards, window lines, and so on. If you can see the nearest corner of the building it is the line that does not appear to slope at the corner. It neither kicks up nor down. The lines above eye level will kick down each way from the corner and those below will kick upward each way from the corner. If you don't see any such lines then you must estimate between roof line and floor line, or whatever presents itself. After some practice you will become adept at finding your eye level.

It is well worth your while to spend some time drawing buildings to learn these principles. Draw your own house or neighborhood from different points of view. Then try drawing it from an imaginary aerial perspective.

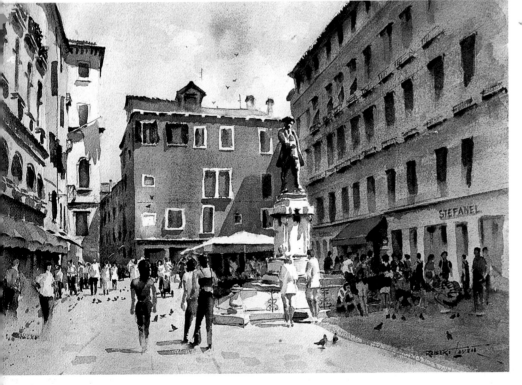

'THE PIAZZA'

(OPPOSITE)
'THE SHAMBLES, YORK, ENGLAND'

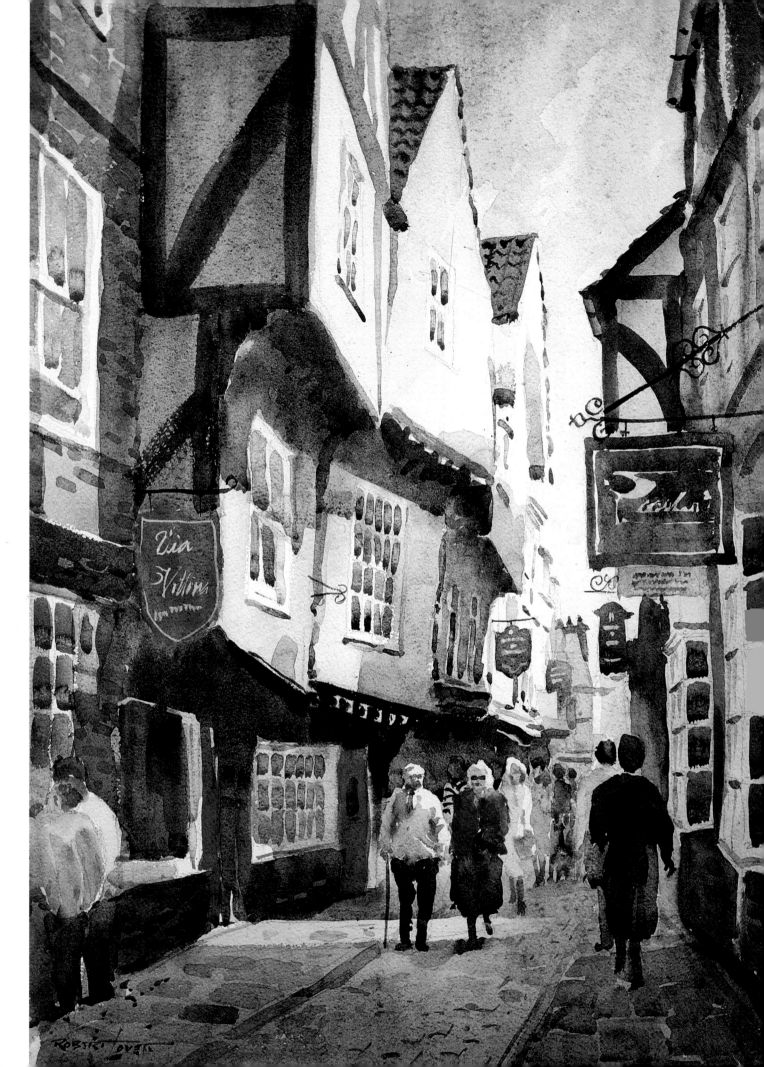

VENICE FISH MARKETS — LOOK HOW THE VANISHING POINTS CHANGED AS I WENT BY ON THE FERRY

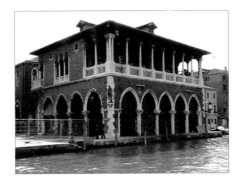
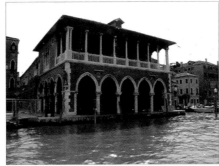
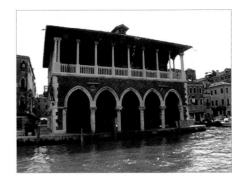

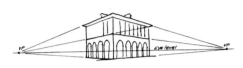
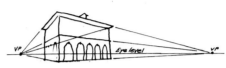
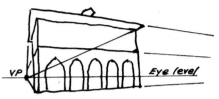

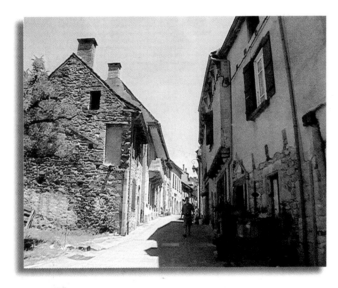

If you are looking along a straight street and all the buildings are parallel (orientated on the same plane), they will all share the same vanishing point. But if there is a bend in the street and the buildings turn accordingly to face the new direction, as they do in this photograph, then a new set of vanishing points will be established.

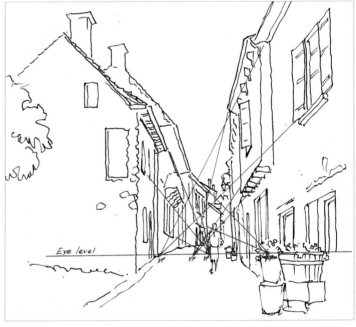

In many of the old European villages the narrow streets twist and turn and the perspective becomes quite complex. Once you understand the principles, then drawing such scenes is not too difficult.

Basic principles of perspective

Buildings provide a convenient subject to explain perspective. Buildings have definite and precise lines, most of which are vertical or horizontal.

Buildings are always constructed on a level base no matter where they are located. This fact allows us to set some guidelines for perspective. We key the lines to our eye level and that becomes the basis for the perspective of each individual drawing.

Venice Fish Markets — a case study

Perspective depends on your point of view. Whether we are standing or seated your viewpoint (the eye level) changes accordingly. If you are looking down at a building

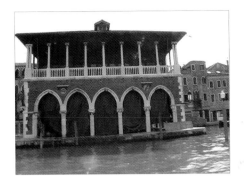

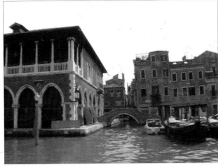

The illustration below shows how the Fish Market in Venice would appear from above and below. See where your eye level is in relation to each position.

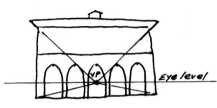

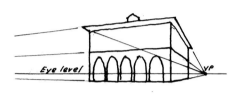

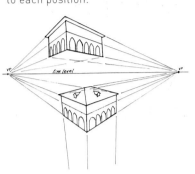

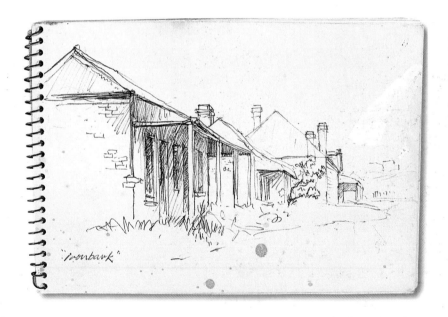

(or any object) or up at it, your relative eye level position changes.

All the horizontal lines of a building that are on the same vertical plane, or parallel, converge to a point called a vanishing point on your eye level.

Each set of lines on a different vertical plane recedes to a different vanishing point.

For example, from the corner of a building we have two vertical planes going in different directions so the lines recede to their respective vanishing point. I took the above pictures of the Venice Fish Markets building as I went by on the ferry. Because my vertical positions did not change, the eye level remained constant, but see what happened to the vanishing points as I the ferry moved past the building. If my vertical position had changed so would the eye level.

USING YOUR JUDGMENT
AN EXAMPLE

In one of my ancient sketchbooks I found this little sketch. It demonstrates the point about using your judgment. I was intrigued by the accuracy of the perspective. It was done over thirty years ago as a quick reference note. I was probably not thinking too much about perspective as I drew, yet somehow I got it right. Eye level and vanishing points are not marked. It was done by observation and using an understanding of the principles. The point is that using perspective becomes automatic after a while, like driving your car: you are not thinking about what your hands and feet are doing, only about where you are going.

PERSPECTIVE IN ACTION

A Street in Venice

1 First I decided what the focal point of the scene was to be — the entrance to the narrow street. Then the buildings were set out using a combination of measurement and judgment. I determined the eye level and extended it beyond my pad to show the vanishing point. This gave me the information I needed to work out the lines of perspective of the buildings.

The drawing looks stiff and clinical but it demonstrates the principle of perspective. When you have mastered perspective, it will not be necessary to extend the lines as I demonstrated here. You can judge the converging lines near enough for painting purposes. But you must have a full understanding first.

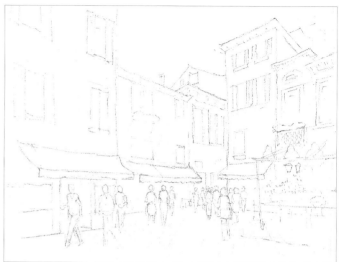

2 Then I continued the drawing, trying for a more spontaneous look. I erased all the guidelines and put a few bends into the lines of the buildings to give the painting the appearance of being "hand made". I sketched in a number of figures and it started to look softer.

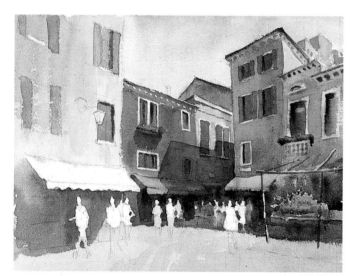

5 The cast shadow ranged between the buildings across the facade and carried over the green awning. When putting colors into shadow like this you must ensure that the color retains its identity. It will have some of the original color but it will be more gray and darker. Window details, flower boxes, and so on, were added.

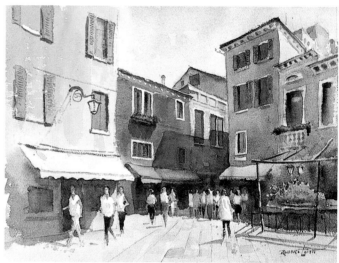

6 Finally the figures were added, massed together as they enter the shadow. The figures in the foreground were more definite. A few final details were added and I took time out to reflect.

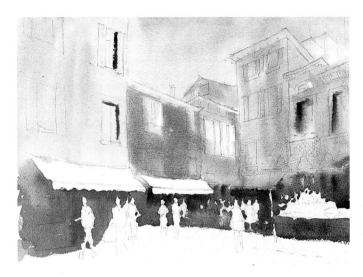

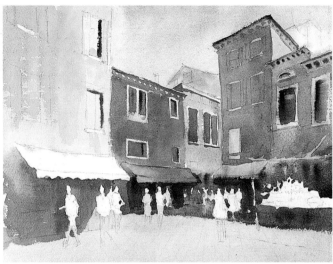

3 The first wash was applied on pre-wetted paper in one go because I didn't want to interrupt the flow. I allowed the colors to blend on the wet paper. Although subsequent washes will sharpen edges, a preliminary wash like this softens the harsh, mechanical nature of the subject. Colors used in this wash were Raw Sienna, Cadmium Red, and some Cobalt Blue and Ultramarine Blue in the dark area at the bottom.

4 I washed over the shadow side of the buildings on the right, putting in the ornamentation under the eaves while the wash was still wet. Then I intensified the color on the face of the red building, and dragged more color over the yellow facade on the left, with my brush held flat to achieve a ragged finish. I also put a light tone over the pavement.

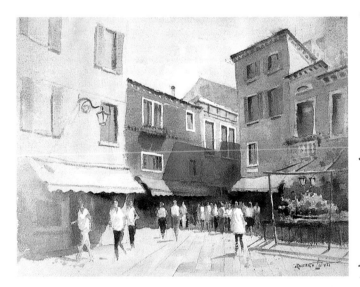

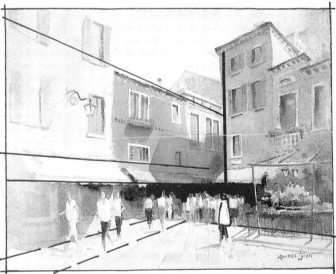

7 After viewing the picture for some time, I did not feel satisfied — it still seemed hard and mechanical. I decided that it required drastic surgery. I dunked the painting in a tub of water and scrubbed parts of the image back. Then, while it was still very wet, I washed over the entire surface with a few different colors, allowing them to fuse. I lifted with a tissue areas that I wanted to retain light. When the work was dry, some of the important dark areas were restored.
I think this rather drastic treatment improved the work.

The significant aspect of this painting is the way the eye is drawn to the entrance to the narrow street where all the people are coming and going. This is because I used the design tactics of using bright colors for the figures and the red wall, as well as strong tonal contrast.

Contrast Direction Color Tonal Value Plan

57

PERSPECTIVE IN ACTION

Positano

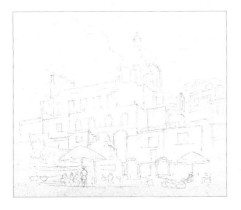

1 Just like all architectural subjects, this one required careful drawing. The main lines had to be accurate, but the details could be put in by eye later.

2 I washed the cold press, 300gsm paper with Raw Sienna and Permanent Rose, leaving a few white highlights. More Permanent Rose, this time with less Raw Sienna, was used towards the bottom.

3 Another glaze was put over this using the same colors but adding Cobalt Blue, this time avoiding the light side of the dome. Another wash was started with the mountain (same colors) and dragged down across the building and the foreground. I used lots of water in these washes to get a more even cover.

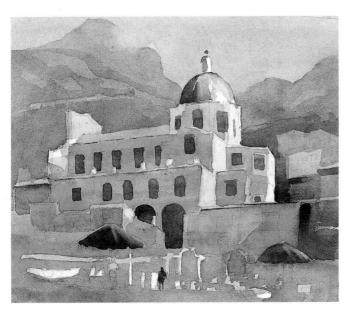

6 The dome and windows were treated with Raw Sienna, Cobalt Blue and Burnt Sienna. The red umbrellas were suggested.

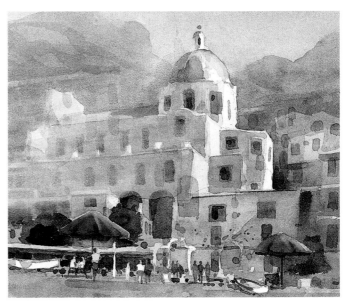

7 At this point I submerged the entire sheet in water and scrubbed back the central part on the main building and the mountains. This was deliberate. I wanted to achieve a soft effect. When the paper was dry, I proceeded with the details along the bottom. I reinstated the windows, and so on, that had been washed back. I made some of these 'out of register', like double images. The dome was also 'echoed' by being made a little out of register. This gave a soft and slightly abstract effect. At that stage I was not sure if it was going to work.

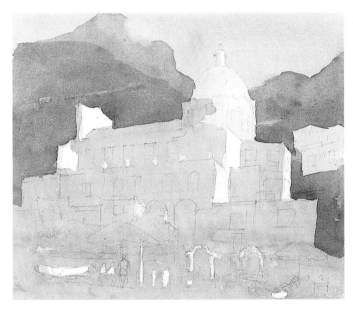

4 The mountains on both sides were washed in and continued down into the shadows of the buildings.

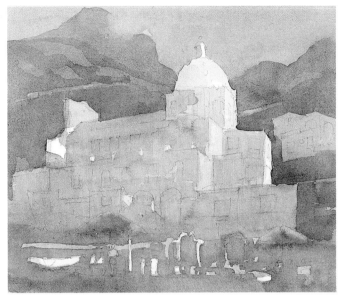

5 Color was intensified on the lower parts.

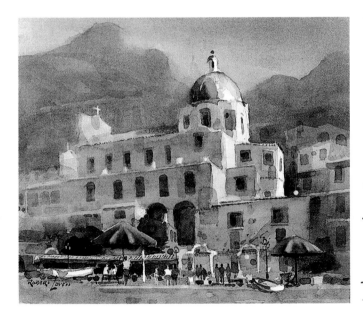

8 With all the final details added, I think it worked out quite successfully. Don't be afraid to try different methods. You learn by experimenting.

Try this, next time you are painting, immerse the paper in water and see what happens. You'll find the paint will not be disturbed unless you agitate or sponge it.

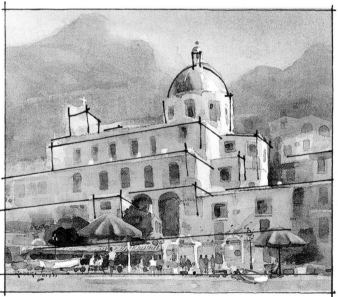

Color Tonal Value Plan

PERSPECTIVE AND SHAPES

Carennac

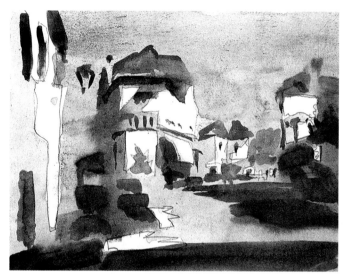

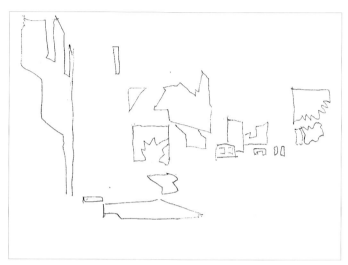

1 This is my tonal sketch showing all light dark and mid tones. The mid-tone is dominant, light tones are next and the darks are the smallest. The overall result is a fairly high-key picture with many darks borderline between dark and mid. Similarly, some of the lights tend toward the mid range. You can see that with our arbitrary division of three tones it is sometimes difficult to allocate some of the more subtle values.

2 Only the light shapes are shown on this sketch and they reveal an interesting abstract pattern. The shapes are all related by their geometric form. The large vertical shape on the left was too dominant so it was reduced in size by putting a shadow on the wall of that building and reducing it in tone slightly to push it more towards mid-tone.

3 Only the dark shapes are shown on this sketch. They form an entirely different abstract pattern that almost tells the whole story. Unlike the lights the dark tones tie together and interlock. Most of the darks are at the high end towards mid-tone, with just a few tiny very darks.

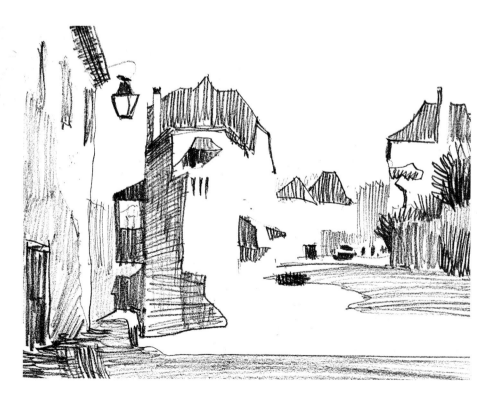

4 The main freestanding building was aligned left of center so that it would become the most important feature of the painting.

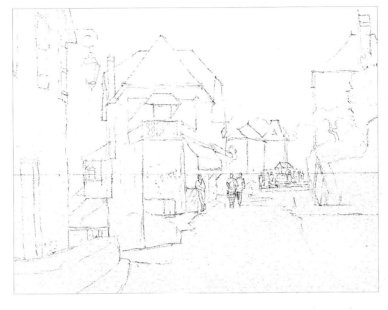

See the variation in size of the negative shapes between the main buildings.

There is contrast in size between the main buildings and the small ones to the right.

The road makes a nice lead in to the entertainment of the figures and cars.

The perspective in this drawing is complex. The main building is wedge-shaped. All the buildings are set at different angles. At least the eye level was easy to locate at head level on the figures. I did not worry about establishing all the respective vanishing points except for the two sides of the main building.

When making a drawing like this you must rely on your judgment and observation. You must also rely on your knowledge of perspective to ensure that the lines lead in the right direction.

5 The first wash covered the entire sheet except for the white areas. I began the wash in the sky with Cobalt Blue, Raw Sienna and Permanent Rose. As I drew the wash down over the road the Cobalt Blue was reduced and a little Burnt Sienna was added.

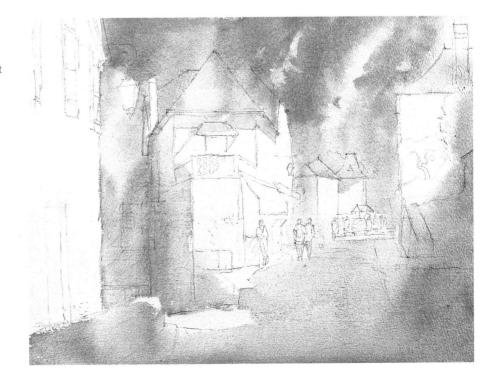

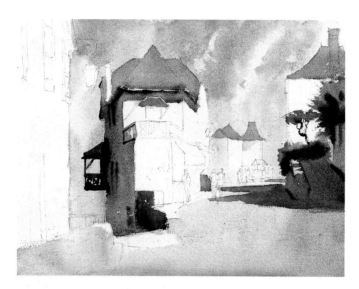

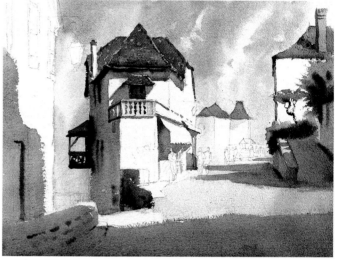

6 When the first wash was dry I began adding the dark areas. The rooftops were Burnt Sienna, Permanent Rose and a little Cobalt Blue. The shadows on the sides of the buildings were the same colors but much less Burnt Sienna. While the wash was still wet I put in some windows and the dark balcony on the left.

7 The shadow across the foreground and up the wall on the left was washed in using the same colors again, but varying the mixture to suit. Ragged edges on this wash were achieved by dragging the paint with the brush held flat. The shadows under the awnings and balustrades on the main building were added. Another wash was put over the rooftops, and I allowed little patches of the previous wash to show through to indicate tiles.

8 Distant trees were added with Cobalt Blue and Raw Sienna and Burnt Sienna. I began adding details of figures, the lamp, doors and windows on the buildings on the left, and the small distant buildings.

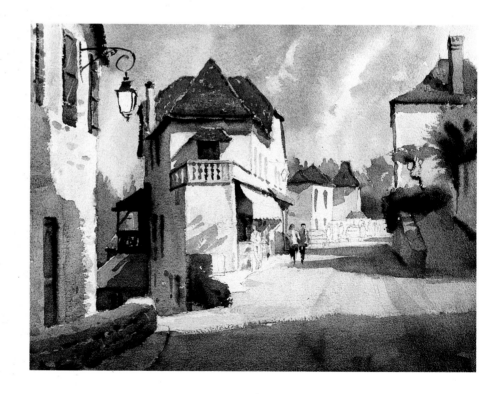

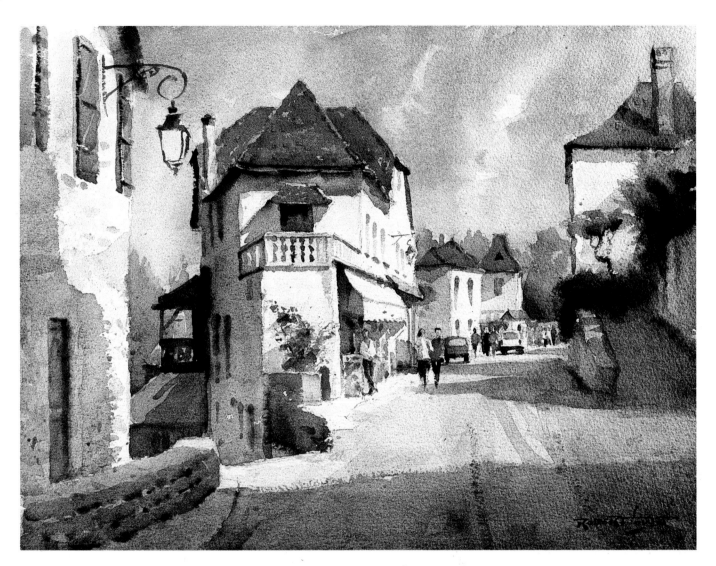

9 Finally, I added more figures, cars and other little details, like all the signs and the bougainvillea growing at the apex of the building. You can see how the main whites on the right side of the main building and the smaller building further back remained the brightest. The other lights were subdued a little. The little touches of bright color and the tiny, strong darks of the figures and cars, and so on, add spice to the picture. Note the repetition of the roof shapes and colors.

Shape

Repetition

Tonal Value

Contrast

Tonal Value
Plan

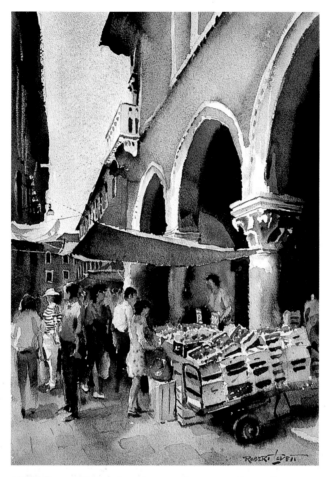

'FRUIT MARKET,
VENICE'

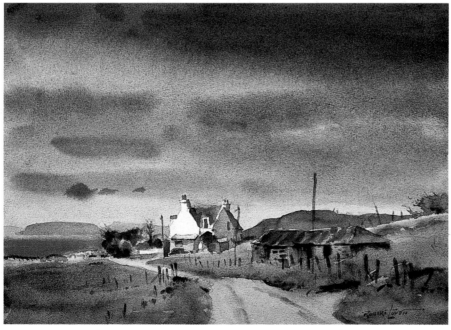

'ISLE OF SKYE, SCOTLAND'

Part 4
Using the tools and arrangements of design

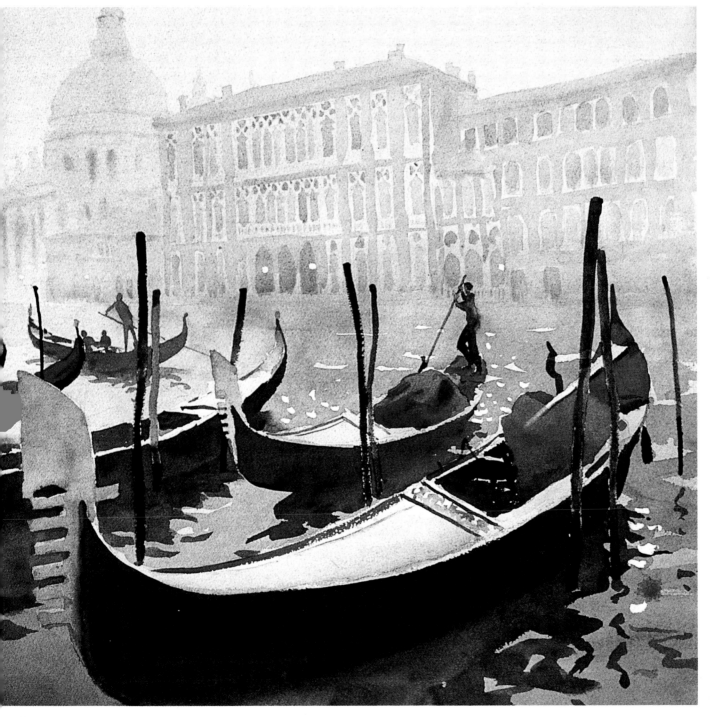

'MORNING MIST'

The design tools and arrangements in action

My series of step-by-step demonstrations show you how to weave the design tools and arrangements into paintings that lead viewers on an exciting journey of discovery.

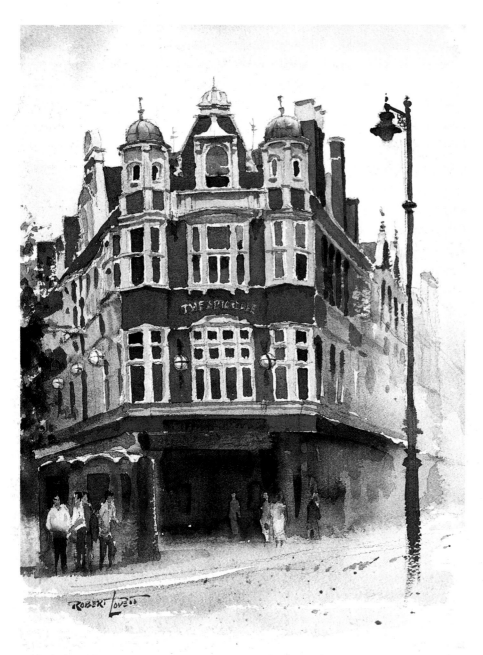

'LONDON PUB'

Watercolor is probably the most satisfying of all mediums. Although difficult in the beginning after practice its mysteries will unfold providing the utmost pleasure for the dedicated. Sure, it is a challenge but it is also sheer delight.

Watercolor is a fun medium. It's up to you to serve your apprenticeship and discover the techniques and the magic that can occur on paper. Then you can approach the work with anticipation and, more importantly, with confidence, because timidity leads to weak, overworked paintings. Boldness is the key to success.

To gain confidence, constant practice is essential. The other factor that paves the way for success, is the initial planning, as we discussed in Chapter 4. Once you are aware of all the marvellous ploys you can use to create a successful design, then you are on your way to mastery of the medium. I suggest you follow the step-by-step demonstrations in this section and take note of how I orchestrated the tools and their arrangement in each design.

How every element in a painting should contribute to the whole

THE TOOLS AND ARRANGEMENTS IN ACTION

The bright color of the foreground reflection, the yellow gondola covers and the central, dark shape of the doorway, lead the eye to the main lights — the two central balconies. These are supported laterally by the blue-toned arched windows. There is repetition in the foreground poles and the row of gondolas, each with its accent of pure pigment. The indistinct dark shape on the right that surround the structure and the figure balances the painting.

Treatment of tonal value, color harmony and texture, dry brush passages and lost and found edges all transform this from an architectural study into a loose painting full of the summer atmosphere of Venice. You can almost smell the place!

REPETITION
See how many of the elements are repeated. The poles, the gondolas, the windows and the balconies.

LET'S SEE WHAT HAPPENS TO THIS PAINTING WHEN I REMOVE SOME CAREFULLY DESIGNED ELEMENTS

- In the altered version I removed the red blinds and the blue windows.
- Changing the color of the covers on the gondolas

seems like an insignificant decision — but look what happens to the overall color scheme when I did it here.

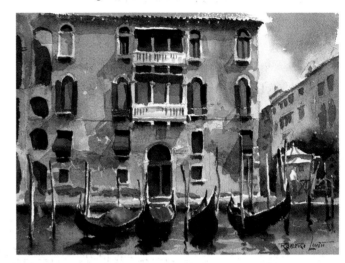

'ANCIENT SPLENDOUR, VENICE'

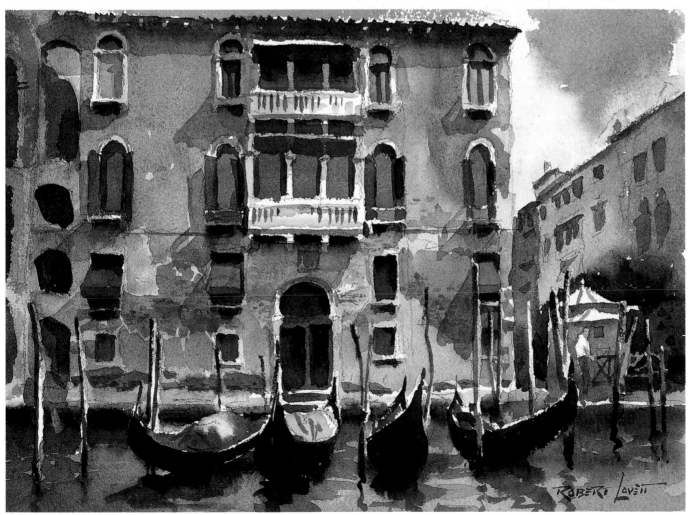

OBJECTIVE

To capture the effects of the sunshine, brilliant colors and strong contrasts. I decided a crisp approach and sharp-edged washes would suit my goals

TECHNIQUE

- Wet-on-dry

THE TOOLS AND ARRANGEMENTS IN ACTION

 Color

 Contrast

 Repetition

 Tonal Value

 Informal Balance

WHAT THE ARTIST USED

Half-sheet of Arches 140lb/300gsm pre-stretched artists' quality watercolor paper
Masking fluid

Brushes

No. 12 squirrel for large washes
Round Sables: 12, 8 and 2
Small Round Sable brushes for details

Palette

Ultramarine Blue	Cobalt Blue
Raw Sienna	Cadmium Red
Permanent Rose	Indian Red
Indigo	

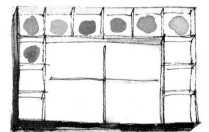

PLACING COLOR IN THE AREA OF MOST INTEREST

Chioggia, Venice

Clues from the scene

Chioggia is about 12 miles from Venice, at the southern end of the Lagoon. It doesn't rate a mention in the usual travel guides, so there are no tourists, no souvenir shops and none of the superficial hype that goes with tourism. Instead, the artist is presented with a real Italian working fishing village full of inspiring subjects.

The canals of Chioggia are flanked on either side by beautiful old buildings and at intervals they are crossed by quaint, arched footbridges.

A variety of multi-colored fishing craft line the narrow waterways and there's plenty of activity as the fishermen unload their catches at the busy markets. Vendors set up their stalls along the sidewalk to sell a variety of goods and produce. It's a vital, colorful scene full of contrasting shapes and textures.

ESSENTIAL PRELIMINARY SKETCHES

These pen and ink line drawings familiarized me with the subject and provided plenty of information about light and shade.

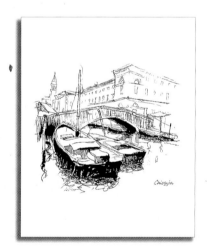
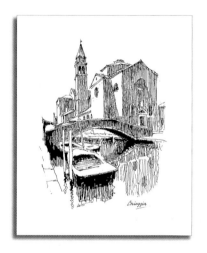

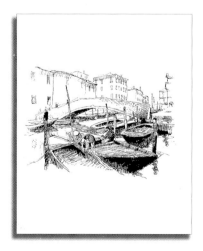

1 This was a complex subject and required careful drawing. The perspective was interesting and challenging. Notice how the two sides of the canal are not parallel — the buildings on the right have a different vanishing point from those on the left!

To preserve areas of highlight I used masking fluid sparingly in just a few small places.

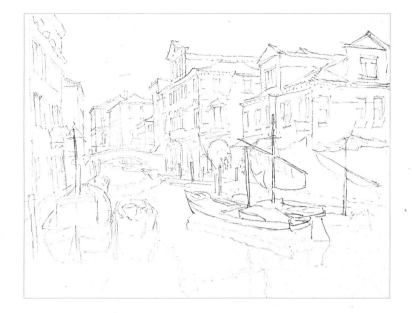

2 With the board raised at an angle of about 30° I quickly applied the initial wash over the entire sheet using a No. 12 squirrel hair brush and lots of water. The colors were Raw Sienna, Cobalt Blue and Permanent Rose, gradating to Ultramarine Blue at the bottom.

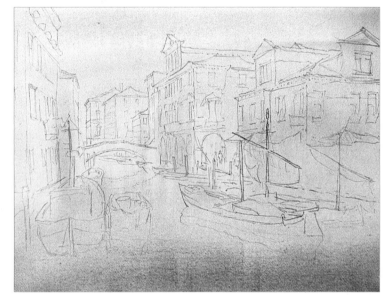

3 The sky was washed in using the same colors (Raw Sienna, Cobalt Blue and Permanent Rose). A hint of Indigo was introduced with the Cobalt at the top.

Next, the rooftops and walls were added using varying mixtures of Cadmium Red, Indian Red and Raw Sienna with touches of Cobalt Blue.

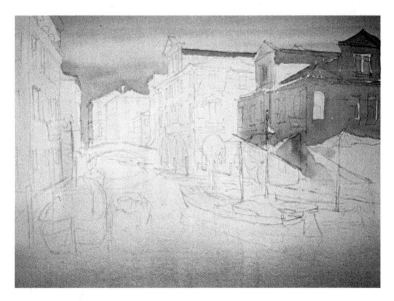

4 Shadows on the buildings were added boldly, with washes that were strong enough to achieve the correct tone in one application. I used more Cadmium Red, Indian Red and Raw Sienna with Cobalt Blue. Some window details were added using mostly Ultramarine Blue and Indian Red. Although these were small areas they were still treated as washes with plenty of water.

A gradated wash of Cobalt Blue and Indigo was laid over the water. While the wash was still very wet, some horizontal bands were suggested to depict the gentle swell in the calm water.

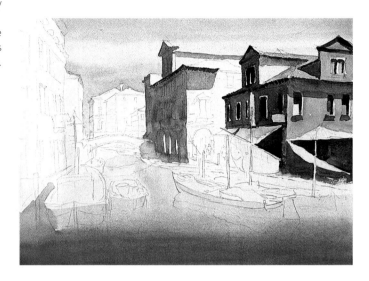

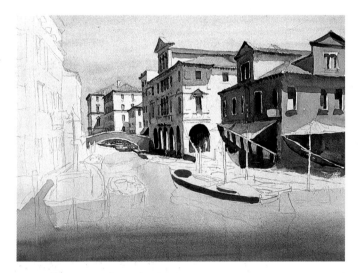

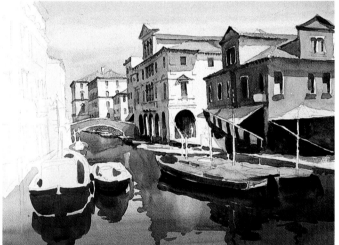

5 The bright red of the boats and sails were put in with pure Cadmium Red. The yellow was Raw Sienna. The arched bridge and the background buildings were added next. To give a sense of distance I made sure that dark accents on those buildings were not as strong as the darks in the foreground.

6 Many little details were washed in with a small brush. I emphasize the word "washed" — some students have a tendency to draw with a dry brush. No matter how small the details are, they must still be treated as washes to retain a "watercolor" character and uphold the unity of the picture.

7 Notice the arrangement of my board. Working on a slant aids the natural gravity of the wash. When making a wash at the bottom, I simply turn my board upside-down, and gravity comes to my aid again.

8 While on the subject of unity, you will notice that almost every wash has a hard, crisp edge. There are very few soft edges and very little wet-on-wet. Maintaining a wet-on-dry approach achieved the desired effect of the brilliant, contrasting light.

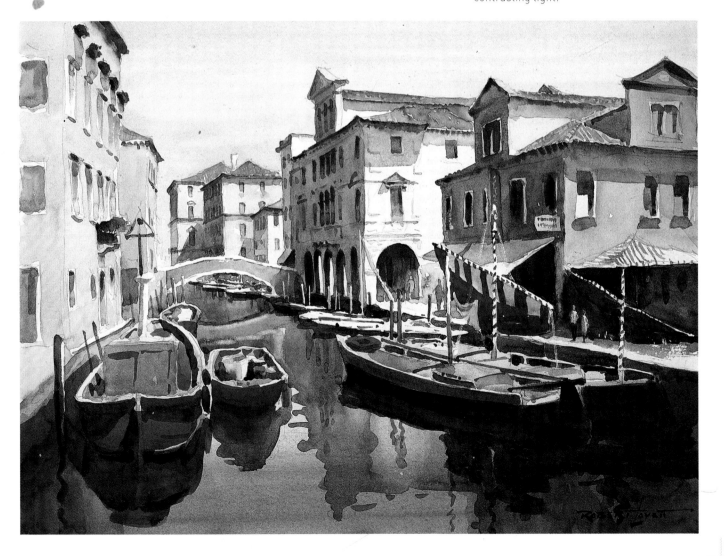

DESIGNING WITH COLOR TEMPERATURE AND LINE
Burano, Italy

Clues from the scene
Color and atmosphere — Burano is a small island in the lagoon near Venice. Like Venice, it is criss-crossed by many canals. The houses are brightly colored and the people take pride in keeping them maintained. Traditionally, Burano villagers lived from fishing and lace making, but these days it is tourism which is the main industry. I was attracted to this subject because of the graceful S-bend leading right into the picture.

1 The little bridge was positioned on the paper above and to the left of center. The two sides of the canal were drawn next making those beautiful S-shaped sweeps. This is the basis of the drawing. The tops of the masses of buildings right and left were roughly indicated; I would work out the detail later.

When drawing a complex subject like this you must see it as simple masses, and work out the basic proportions of these. You can see on the drawing where I have marked my eye level, which falls just under the deck of the bridge, and will coincide with head level of all figures. The perspective is a complexity of vanishing points as the buildings constantly turn to run parallel with the winding canal. I established a vanishing point for the first row of houses on the right and from there on relied on judgment and observation.

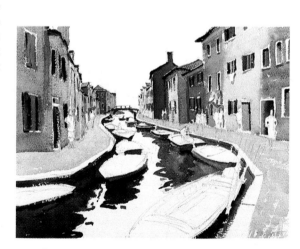

4 Beginning with the little bridge, darks were run down each side of the canal. The canal wall, the sides of the boats and the reflections were all treated as one, the colors being allowed to merge and run together.

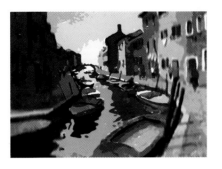

TONAL VALUE PLAN

The tonal value sketch shows how I balanced the main masses. This is informal balance — there is a large mass on the right comprising buildings, reflections, boats and pavement balanced by a smaller but similar mass on the left.

The focal point set above and to the left of center is the little bridge. Here is the point of greatest tonal contrast and this is where the "S" bend of the canal leads the eye.

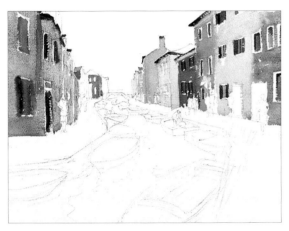

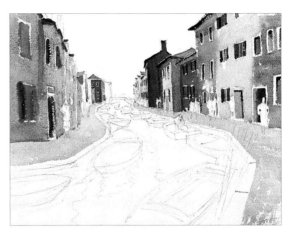

2 I wanted to take advantage of the rough paper so did not use an overall wash. Instead, I began right in on the buildings, again regarding them as simple masses. The colors were allowed to merge. I avoided distinct boundaries on many of the buildings while others were sharply defined. Windows were already being indicated.

3 Those buildings just to the right of center showing shaded ends were sharply defined when I added the shadows. A wash was carried down right across the pavement. Burano is a riot of color with boats and houses of many different colors and that makes it difficult to adopt a dominant color or a harmonious scheme. I decided the best approach was to make the warm colors dominant and introduce cool blues for contrast. So my palette for this painting was wide ranging.

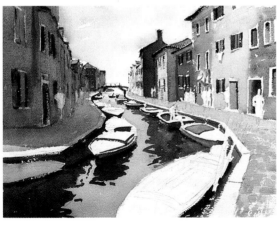

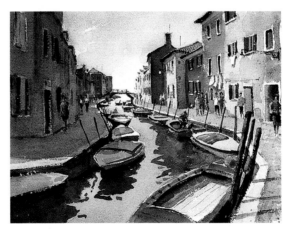

5 The sky was washed in with Cobalt Blue, Permanent Rose, and towards the bottom, Raw Sienna. The horizon disappears into a haze of light. The area around the bridge was left white for the greatest contrast. A wash was put on the water using the same colors as for the sky but becoming stronger towards the bottom of the picture. I ran a heavy shadow over the buildings on the left and down across the pavement. The color was warm at the top and much cooler as it crossed the pavement, picking up blue reflected from the sky. The colors on the building walls were the same colors as originally used, plus some Cobalt Blue and Permanent Rose.

6 It was then just a matter of working on the details. The tops of the boats, the posts, the figures, and all the other little bits and pieces, finished off the picture.

OBJECTIVE
To capture the beautiful facade of the building and create a scene full of character, with a focal point defined by color

TECHNIQUE
- One section at a time direct on rough paper
- Dragging the brush to create rough edges
- Wet-into-wet washes
- Prewetted paper
- Colors mixed on the paper

THE TOOLS AND ARRANGEMENTS IN ACTION
In this demonstration we pay particular attention to the following design tools and arrangements:

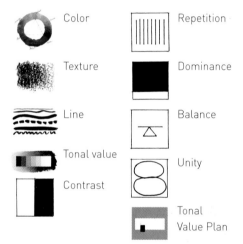

Color • Repetition
Texture • Dominance
Line • Balance
Tonal value • Unity
Contrast • Tonal Value Plan

WHAT THE ARTIST USED
Paper
Arches 140lb/300gsm Rough

Brushes
No. 12 Squirrel
Round Sables: 12, 8 and 2
½" Flat Sable

Palette
Ultramarine Blue Cobalt Blue
Raw Sienna Permanent Rose
Indian Red Burnt Sienna

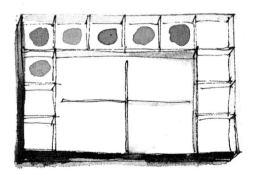

MAKING A POWERFUL STATEMENT WITH COLOR AND TEXTURE
Vittorio, Veneto

Clues from the scene
Vittorio Veneto is a historic, medieval village in the north of Italy. The cobblestone streets and the beautiful architecture provided the inspiration for this and other paintings. I was attracted to this old building because of the texture of the facade. When the sun is at a certain angle, every little projection casts a diagonal shadow down the wall.

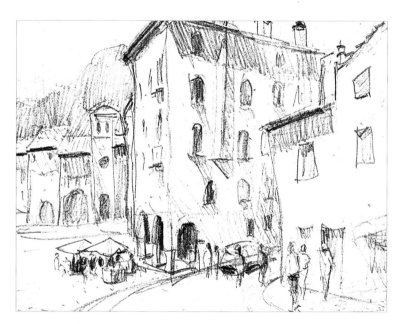

TONAL VALUE SKETCH

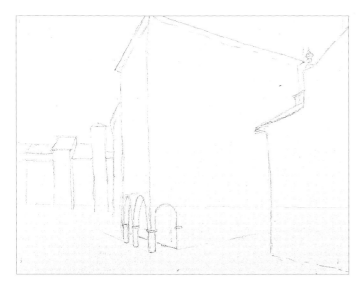

1 I established the main vertical at the corner of the building and put this line off center. The sunlit facade to the left of the line would be the main focal area. I wanted it left of center. At this point I also established the eye level.

Everything was then positioned with regard to the initial vertical line. I continued drawing, watching the proportions and angles carefully. Every line was drawn freehand. When you draw buildings, don't aim for dead straight edges, let them meander a little and the painting will have more character.

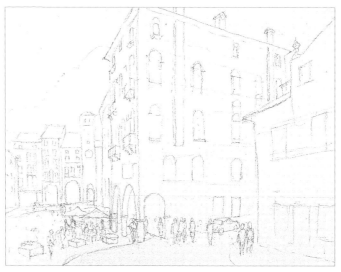

2 I continued with the drawing, putting in all the details of windows, and so on. I indicated quite a few figures and some large umbrellas. This would be the most colorful area, just adjacent to the base of the sunlit facade (the focal point).

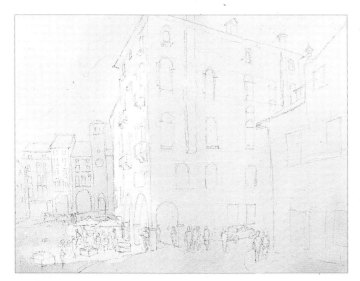

3 Using lots of water I washed all over the paper leaving only those area that were to remain white. The colors were dropped into the water with variations of Raw Sienna, Permanent Rose and Cobalt Blue. You can already see how important the reserved whites are.

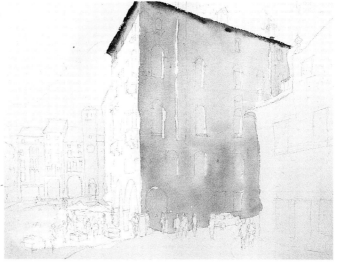

4 I put a wash over the shaded side of the main building. I wet the paper before applying the color. I carefully avoided all the little highlights on the windows and chimneys. Color was varied and mixed on the paper. Cobalt Blue, Permanent Rose, Raw Sienna and a touch of Burnt Sienna were used here. The dark eaves line was added while the wash was still wet. I used a fairly dry brush with Ultramarine Blue and Indian Red. (These are sedimentary colors and they do not run too far when used like this.)

5 I moved ahead and put in the details of windows and shadows on the main wall. I wanted to get this effect early because the beautiful facade was the inspiration for the painting. I like the way the shadows slide diagonally across the wall surface.

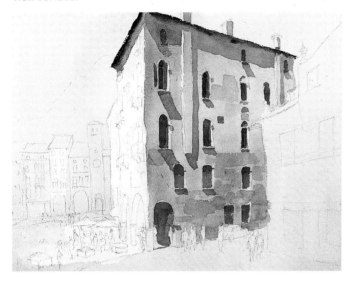

6 I turned the board upside-down to wash in the sky. I did not want the bead along the roof line of the far buildings and I wanted the sky darker at the top. That was easier to achieve with the darker area at the bottom of the slope. The colors used in the sky were Permanent Rose, Cobalt Blue and Raw Sienna.

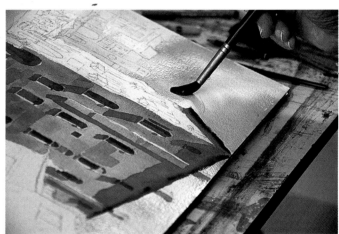

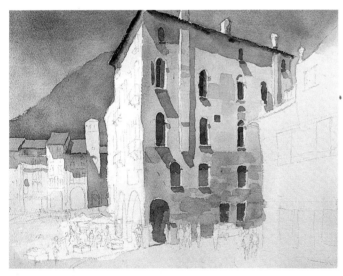

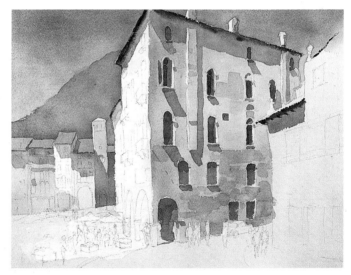

7 I put in the red roofs (Burnt Sienna and Permanent Rose) and let the washes overlap into the sky area. When this had dried I washed in the mountain using the same colors as for the sky. I left a hard edge along the top of the roof line. The shadows on the face of these buildings were put in at the same time with virtually the same wash I used for the mountain. See where I softened the edge at the top of the mountain in a couple of places.

8 The lower part of the mountain was pre-wet and a stronger, warmer wash was put in. This brought that part of the mountain closer and gave more contrast with the red roofs. I then worked all over putting in details, windows, balconies, cast shadows, archways, and so on.

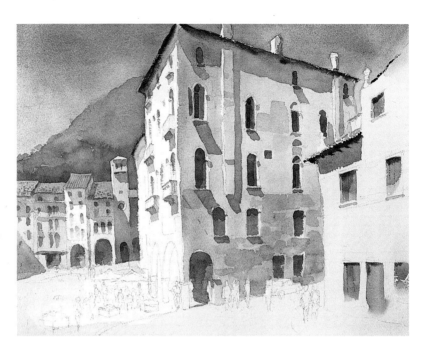

9 This was where the fun really began. I applied the strong darks in the archways near the corner of the main building and the brightly colored figures. The colors, the strong darks and the contrast with the sunlit face of the building form the center of interest.

Up to this point most of the colors used throughout the picture were in the cool red, violet and blue range. Now you can see the effect when I introduced the brilliant reds, and particularly the bright yellow, which is the complementary color of the blue-violet shades. Also notice how the reds bounce around the subject and echo over the window shutters and tile roofs.

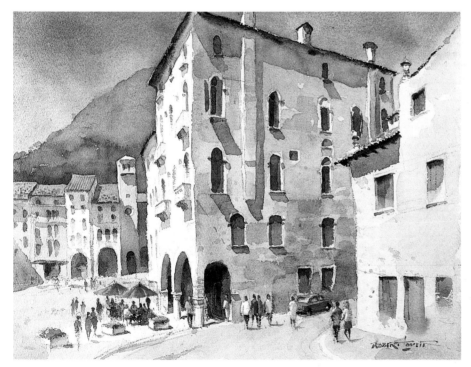

TONAL VALUE PLAN

10 I decided to strengthen the tone on the shaded face of the main building, particularly in the lower right, to set it back from the near building. This design features dominant mid-tone, contrasting with the smaller lights and the very small darks. Color dominance is cool reds opposed by some blues. In direction the vertical dominates. The design is capped by strong, oblique lines at the top of the main building which, together with the line of the mountain, forms an apex. The oblique on the right is counteracted by the opposing oblique roof line of the near building. The bright colors of the figures and strong darks of the arches make a powerful statement across the base and draws the eye. Visual entertainment over a wide area is provided by the repeating pattern of windows, figures, and so on. Then there are areas of relaxation, such as the sky and foreground pavement.

TECHNIQUE

- One section at a time directly onto rough paper
- Dragging the brush to create rough edges
- Lifting color with tissue

THE TOOLS AND ARRANGEMENTS IN ACTION

In this demonstration we pay particular attention to the following design tools and arrangements:

 Unity through shadow

 Tone

Contrast

Repetition

Dominance of verticals

 Line

Balance

 Color

WHAT THE ARTIST USED
Paper
Arches 140 lb/300gsm Rough

Brushes
Round Sables: 12, 8 and 2
½" Flat Sable

Palette

Ultramarine Blue	Cobalt Blue
Phthalo Blue	Cadmium Yellow
Raw Sienna	Permanent Rose
Cadmium Red	Burnt Sienna

UNIFYING A COMPLEX SUBJECT WITH A BAND OF SHADOW
The Rialto, Venice

Clues from the scene
When I looked through these blue and green striped poles to The Rialto Bridge what I saw was a very busy, complex pattern. Nevertheless, I was compelled to paint it.

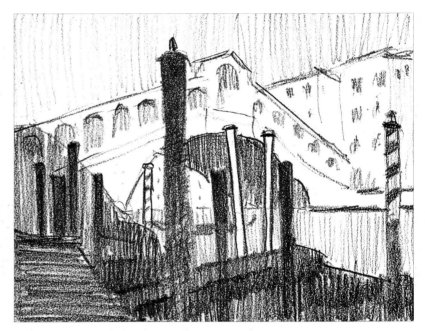

TONAL VALUE SKETCH
The sketch shows how this complex subject was organized into areas of tone. The shadow is recognized as one integrated mass that occupies roughly one-third of the total area, forming a triangle in the lower left corner. Those dark poles thrust upward into the light and mid-tone areas, latching onto the shadow under the bridge, locking it all together. You can see from this how important the tonal sketch is in helping to simplify and arrange complex subjects.

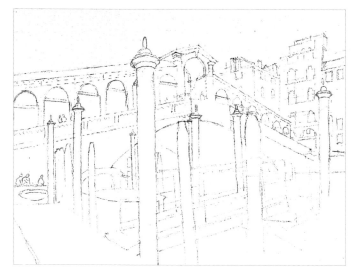

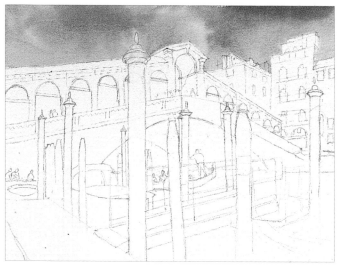

1 I spent a long time on the drawing, which had to be correct. Because of the angles of the bridge the perspective is difficult but you can see how the size diminishes as it recedes into the distance. (Revisit the chapter on perspective if you are unsure.)

It was important to place the major dark pole off center, so this is where I began the drawing. Then I made this my reference point as I marked in other prominent points to establish the scale of the image and its correct location on the sheet. Working like this made the drawing relatively easy. It was then just a matter of continuing carefully.

2 I decided to use a different approach which would exploit the characteristics of the rough paper. Instead of using an overall basic wash as I so often do, this time I painted one section at a time direct onto dry paper. This lends itself to a rough appearance. I also intended that some of the washes would have ragged edges made by dragging the brush.

The sky was washed in using Cobalt Blue, Permanent Rose and Raw Sienna.

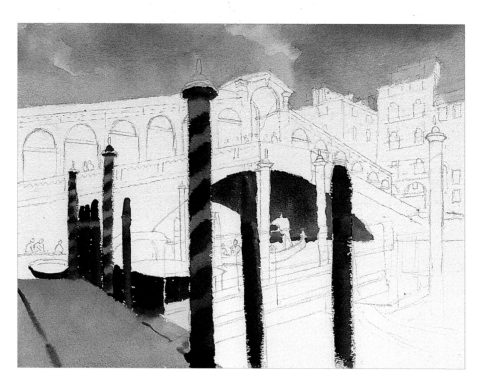

3 By applying the foreground darks at this stage, the strong contrast was established. The poles were treated with rough edges as mentioned earlier. The striped poles were first washed in completely with a green made from Phthalo Blue and Cadmium Yellow. The dark stripes were added into the wet wash with pure Ultramarine Blue on a semi-dry brush. The archway under the bridge was Ultramarine Blue and Cadmium Red, blending into Burnt Sienna as it lightened off at the bottom. The same combination of colors, but with varied proportions, was used for the decking and other shadows.

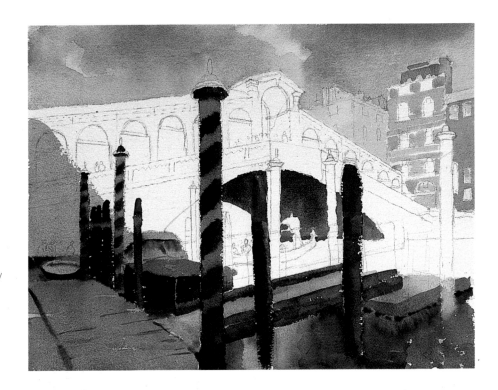

4 Cobalt Blue, Permanent Rose and a little Burnt Sienna were used for the shadow over the left side of the bridge. The decking ramps of Cobalt Blue, Cadmium Red and some Ultramarine Blue were added, as well as the dark reflection in the water, which was allowed to blend in places with the deck. The reflection was mainly Ultramarine Blue and Cadmium Yellow with some burnt Sienna. The buildings on the right were washed in and I carefully avoided the windows. The colors were Cadmium Red, Burnt Sienna and Raw Sienna.

5 Then the poles in the sunshine were added, using the same colors and method as those in shadow but keeping them in a higher key. A narrow highlight was lifted out down the center of each pole by wetting that section and dabbing with a tissue. The bridge was left completely white. The details were added with a small brush and warm grays mixed from leftovers on the palette.

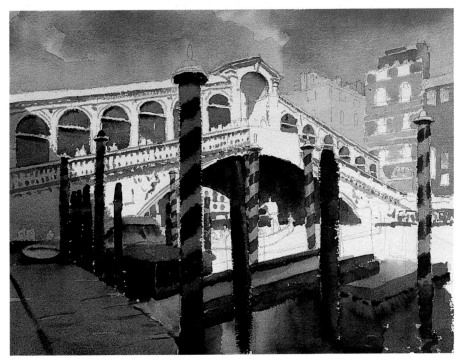

This painting has powerful tonal contrast from our viewpoint as we look out into the bright sunshine.

There is dominance of vertical direction counteracted by the oblique lines of the bridge which climax at the apex near the top of the dominant foreground pole.

The repeating patterns cover almost the entire sheet.

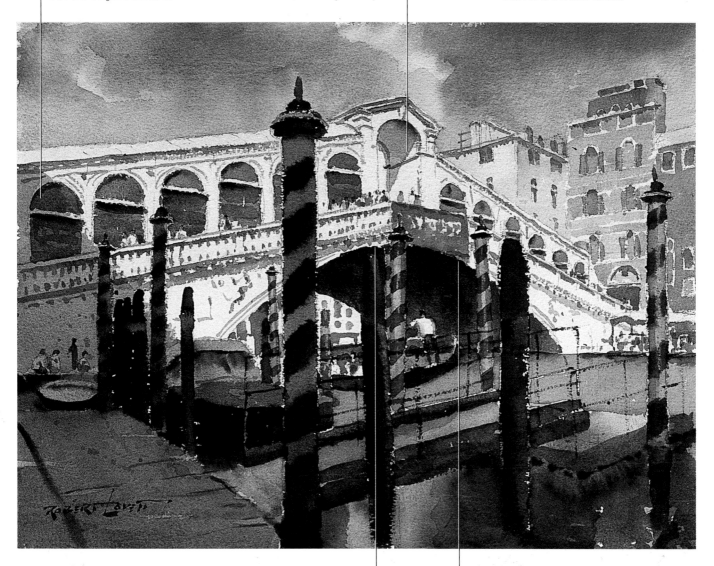

6 The many small details, the windows on the far buildings, the gondola, the numerous figures and the handrails were added next. Finally, the red banner and the red figure in the gondola provide the necessary complementary color accent. The red building on the right was strengthened a little to repeat the red of the banner. In spite of the busy nature of this design I feel that it works well, and is very entertaining.

The lines are predominantly straight, but the main arch and the curves in the small arches over the windows give relief.

Notice how that small bright red banner is such an important color note. It is echoed by the pink building on the right.

OBJECTIVE
To make a powerful, dramatic scene with contrast

TECHNIQUE
- Wet-in-wet washes
- Glazes over dry paper
- Color mixing on the paper

THE TOOLS AND ARRANGEMENTS IN ACTION
In this demonstration we pay particular attention to the following design tools and arrangements:

 Tonal Value Plan — dominant mid tone — less dark and small lights

 Shape — Contrast of geometric shapes of the buildings with the soft dominant shapes of the landscape

 Direction — The powerful horizontal line of the buildings dominates

 Contrast — is found in the vertical of the driveway and the obliques of the trees and hilltop

WHAT THE ARTIST USED
Paper
Arches 140lb/300gsm Cold Press

Brushes
Round Sables: 12, 8 and 2

Palette
Ultramarine Blue
Cobalt Blue
Raw Sienna
Cadmium Red
Burnt Sienna
Indigo

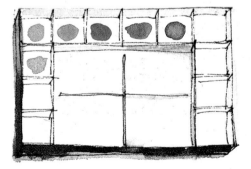

MANIPULATING TONE, SHAPE AND DIRECTION FOR DRAMA
Welsh Farmhouse

Clues from the scene
A found this typical little North Wales stone cottage, with its chimneys at each end and the outbuildings while on a painting excursion. I decided to dramatize the scene by putting a heavy cloud shadow behind the buildings and lighter shadow in the foreground.

You can see the effect of this in the tonal sketch.

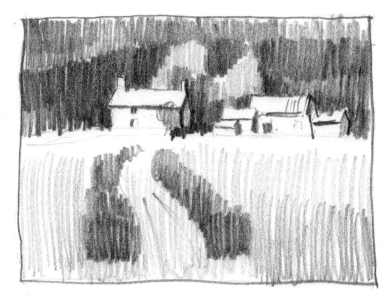

TONAL VALUE SKETCH

DESIGN PLAN
The geometric shapes of the buildings contrast with the soft dominant shapes of the landscape. The powerful horizontal line of the buildings dominates. Contrast is found in the vertical lines of the driveway and the oblique lines of the trees and hilltop.

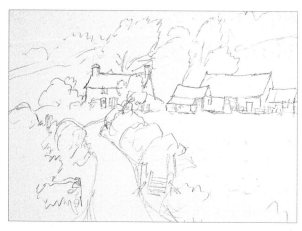

1 The drawing was straightforward. I tried to express the quaintness of the buildings by making them a little less than perfect. Some of the roof ridgelines were allowed to sag.

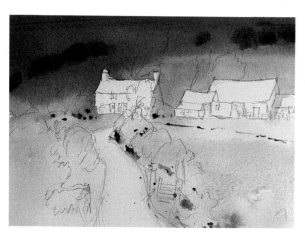

2 A wash of Indigo and Burnt Sienna was started at the top and changed by adding Raw Sienna and decreasing the Indigo towards the bottom. Only the sunlit parts of the buildings were left white. Some darker areas were dropped in while the wash was wet.

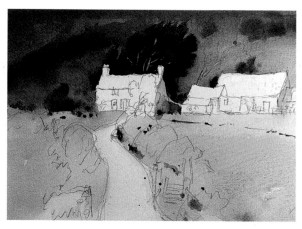

3 The trees and the hill behind the buildings were treated with strong washes of Raw Sienna, Burnt Sienna and Ultramarine Blue. This really enhanced the contrast with the buildings.

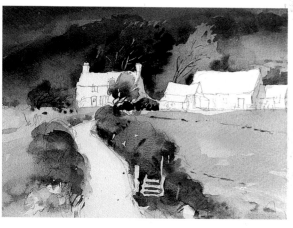

4 The foreground was treated with another wash of Raw Sienna, Cobalt Blue and little Burnt Sienna over the grassy area. The hedgerows on each side of the drive were added with the same colors. The fence posts and the gate were left alone.

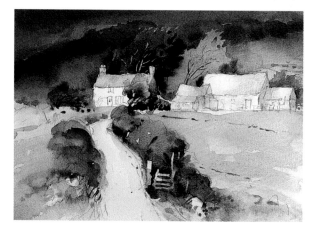

5 I worked on the buildings with Raw Sienna, Burnt Sienna and a little Cadmium Red. The shadows on the ends of the buildings were painted crisply with Burnt Sienna and Cobalt Blue.

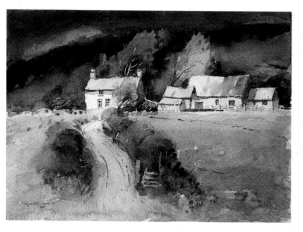

6 Another wash of Cobalt Blue and a little Burnt Sienna was run right across the foreground, including the roadway, gates, and so on. More color was added to the roofs of the buildings. Details of windows and doors and tree trunks were added. Finally, I put another deep wash of Indigo and some Burnt Sienna over the background.

OBJECTIVE
To play with heavyweight paper to create soft beginnings with hard edges and dry brush effects later

TECHNIQUE
- Painting on very wet paper
- Wet-on-wet washes
- Hard edges
- Dry brush effects

THE TOOLS AND ARRANGEMENTS IN ACTION
In this demonstration we pay particular attention to the following design tools and arrangements:

 Tone — Mid tone dominance

 Color dominance — Red side of the spectrum

 Direction — Oblique lines dominate and converge carrying the eye inwards to the focal point

 Informal Balance — The smaller mass of building on the far right balances the larger one on the left. The light of the sky reflects in the water forming a vertical band off center. The gondola (the center of interest) is well positioned within this band

WHAT THE ARTIST USED
Paper
Arches 300lb/600gsm Rough

Brushes
2" Flat Squirrel
Round Sables: 12, 8 and 2

Palette
Ultramarine Blue
Cobalt Blue
Raw Sienna
Cadmium Red
Burnt Sienna

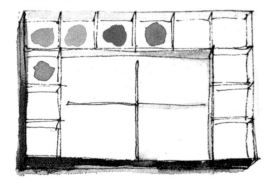

ACHIEVING CONVINCING DEPTH THROUGH BALANCE, DIRECTION, TONE AND COLOR
Quiet Canal, Venice

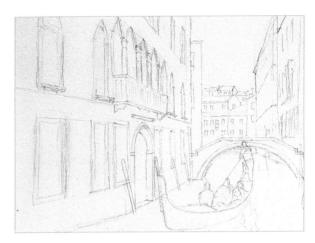

1 The perspective in this scene is complex even though it looks simple at first glance. That building on the left takes a bend near the arched doorway. The one on the right takes a bend by the bridge. It means there are multiple vanishing points — a common situation for the old European cities. However, we wouldn't want it any other way because it's part of their charm.

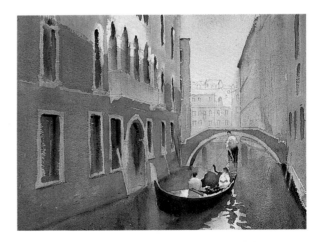

4 Then the right side of the paper received the same treatment as I strengthened washes and defined edges. I began adding the far buildings and the bridge. The figures in the gondola were added using strong tones. I deepened the shadow on the wall on the left particularly on the window frames and balustrades.

The lower part of the wall received some French Ultramarine Blue to give it a stained appearance and to prevent monotony.

Clues from the scene

You may think I have a favorite city. You would be right. No matter how many times I return to Venice I am always captivated. I love the hustle and bustle of people walking everywhere. There are no automobiles. The beautiful old buildings on the waterways create a truly magical atmosphere.

My subject was a very quiet little back canal overwhelmed by the red walls on either side.

TONAL VALUE PLAN

2 The paper was immersed in a tub of water for about ten minutes. Then I took it out and while it was very wet the first washes were applied. The result was very soft. It is a peculiarity with 600gsm paper, that diffusion like this only occurs when there is actual water on the surface. Although the paper has a large capacity to hold water for a very long time you can still create hard edged washes.

Colors used here were Cadmium Red, Burnt Sienna, Raw Sienna and French Ultramarine Blue.

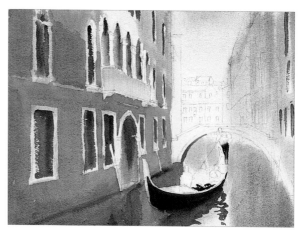

3 I intensified the washes on the left. It is possible to wash over again even though the underlying paper is quite wet. On lighter papers you would not attempt this until the surface was absolutely dry.

The darks were added with French Ultramarine Blue and Burnt Sienna. I was getting quite sharp edges even though the paper was still very damp.

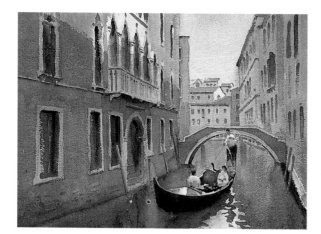

5 By this time the paper was almost dry, but that does not really make any difference to the way this type of paper works. I then added the many minor details of windows and balustrades.

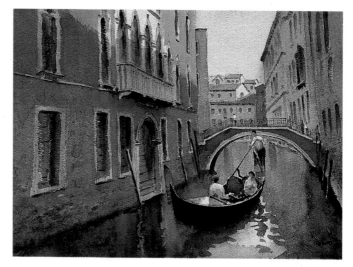

6 You can still see evidence of the soft beginnings, but hard edges and dry brush effects were a feature of the final work.

'HYDRA DOCKSIDE, GREECE'

Designing for different subjects

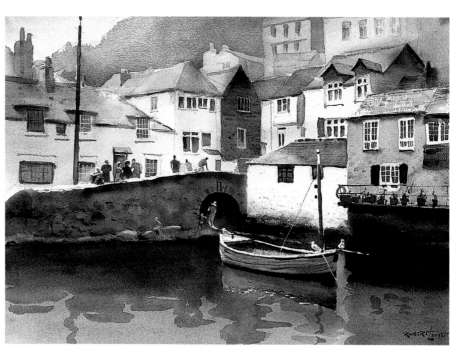

'POLPERRO, ENGLAND'

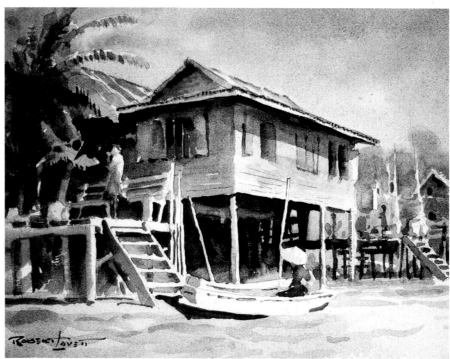

'THE KLONGS OF BANGKOK'

Chapter 7

Designing for mountains and rivers

This is where we move into the realm of the sublime and into subjects far removed from the ancient cities of the world. This is where we have the opportunity to work with scale to show Nature at her loveliest, and where we have the chance to practice our skill at painting the effects of light on the fast flowing waters of the rivers.

While we thrill to the color and sights of the towns, it is the landscape that gives us a chance to suggest atmosphere and mood, to evoke sunstruck vistas, to go wild with dramatic skies, or to make a profound statement about our sacred environment.

However, the wide open spaces present the same problem as do the subject-crammed canals of Venice — you must decide what to put in and what to leave out. And you do that by design.

OBJECTIVE
To depict the purity of snow and the jagged nature of the mountains

TECHNIQUES
- Clean, sharp edged washes
- Soft fusion

THE TOOLS AND ARRANGEMENTS IN ACTION
In this demonstration we pay particular attention to the following design elements

 Repetition Contrast

 Shape Color

 Balance Tone

 Value

WHAT THE ARTIST USED
Paper
Arches 140lb/300gsm Cold Press

Brushes
Round Sables: 12, 8 and 2

Palette
Ultramarine Blue
Cobalt Blue
Aureolin
Burnt Sienna
Permanent Rose

MOUNTAINS
Near Arrowtown, New Zealand

CLUES FROM THE SCENE
Apart from this subject being a scene that took my breath away, the thing that caught my eye was the many repeating triangles.

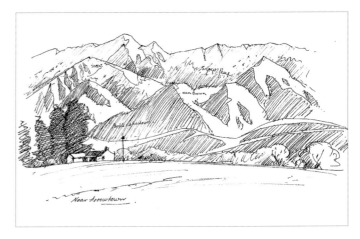

TONAL VALUE SKETCH
This is mainly a mid-tone painting with the strongest darks (the trees), placed near the lightest lights (the buildings).

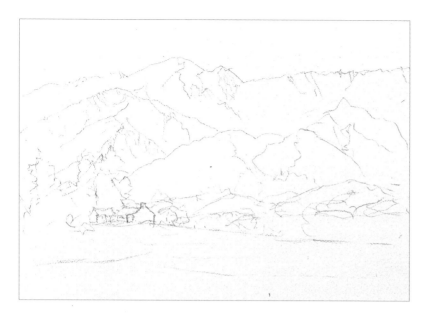

1 In setting out the design on the watercolor paper I kept the idea of the repeating triangles in mind. I took every opportunity to emphasize the triangular theme. It was an intricate subject and required careful drawing.

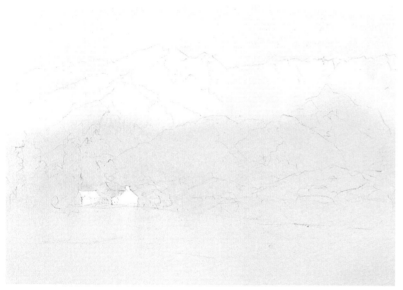

2 Cobalt Blue, Aureolin and Permanent Rose made up this first wash. The colors were mixed on the paper which had been prewet. I made sure to leave the white areas untouched. As I worked the wash downwards, the proportion of the colors was varied to produce a warmer effect.

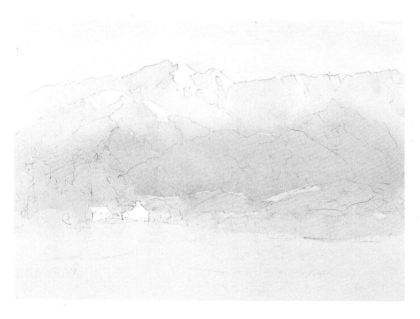

3 Cobalt Blue was carefully applied to the mountaintop producing a hard edge. Again, I avoided the areas of sunlit snow. The wash was again warmed up and carried down to about one-third of the way from the bottom of the paper. I then had three distinct bands of preliminary color, and the scene had been set.

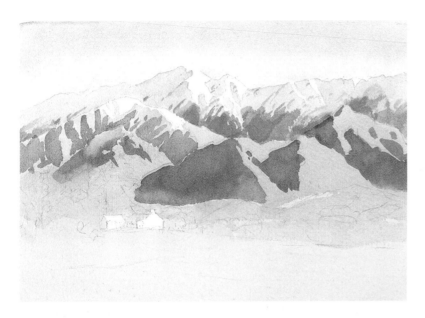

4 The shadows on the foothills were put in with Ultramarine Blue and Permanent Rose. Most of these little washes have hard edges to help depict the sharpness of the ridges.

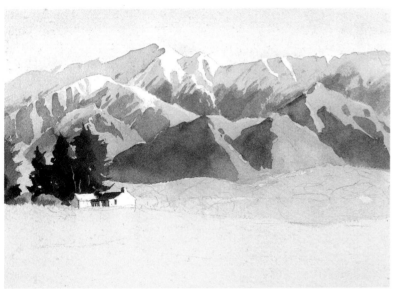

5 The tone of the sunlit sides of the mountains was lowered with another wash of Cobalt Blue and Permanent Rose. The farmhouse and pine trees were added. The pine trees were painted with Aureolin, Permanent Rose and Ultramarine Blue.

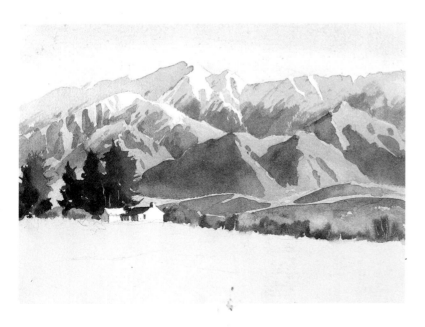

6 The low foothills and the line of brightly colored basket willows were put in together to achieve a soft fusion. I was still using the same three colors, just varying the proportions.

7 Because the central band of interest is so busy a simple foreground was required. This was washed in with Burnt Sienna, Aureolin and just a touch of Cobalt Blue.

Clean sharp edged washes depict the purity of the snow and the jagged nature of the mountains.

The triangular shapes of the mountains were repeated constantly, and suggested again in the buildings.

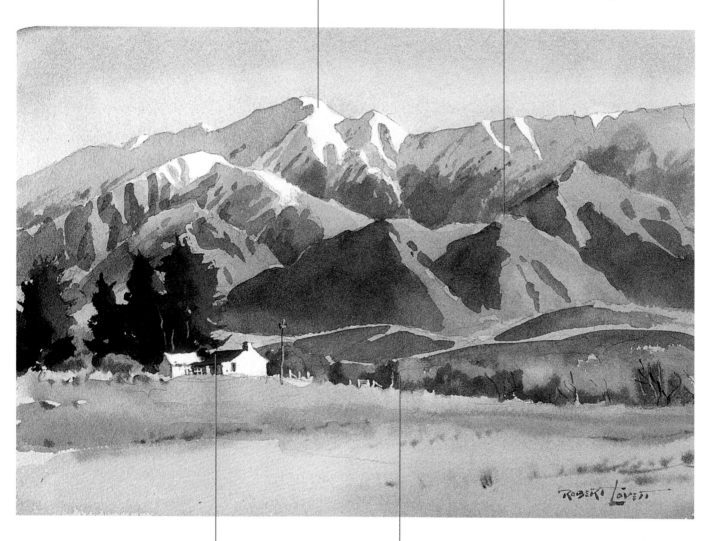

There is an overall balance of cool and warm colors.

The red roof makes a strong contrast to the white of the end wall.

The line of willows stretching across the lower one-third of the picture adds a bright color note.

The uneventful foreground and sky give relief from the very busy middle section.

OBJECTIVE

To emphasize the water surging around the rocks

TECHNIQUES

- Wet-on-wet
- Mixes blended on the paper
- Blotting
- Modeling
- Shaping
- Texturing
- Dragging
- Splashing
- Dabbing
- Scraping

THE TOOLS AND ARRANGEMENTS IN ACTION

 Gradation

 Tone — Low key

 Dominant darks

 Color — cool greens and blues are dominant with just a few small warm colors for contrast

 Value

OBJECTIVE

To achieve gradation from dark at the top to mid-range, then to white, and back to dark at the bottom. This plan left the white running across at an oblique angle.

WHAT THE ARTIST USED

Paper

Arches 140lb/300gsm Rough

Brushes

½" and 1" Flat Sables
Round Sables: 12, 8 and 2

Palette

Ultramarine Blue
Cobalt Blue
Phthalo Blue
Aureolin

Permanent Rose
Burnt Sienna
Indigo

White gouache for vitality in the water

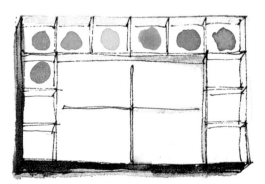

RIVERS

Gallatan River, Wyoming

CLUES FROM THE SCENE

I have spent many weeks painting in this beautiful part of Montana and the Rocky Mountains in summer, fall and winter. The seasons are strikingly different but each has its own charm.

The Gallatan River rises in Wyoming (Yellowstone) and descends quickly through Montana. As it gathers the melting snows it can become a wild and raging torrent and that is the clue to this painting.

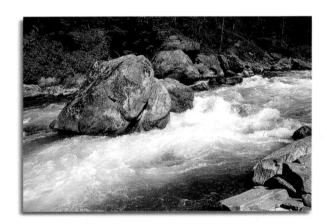

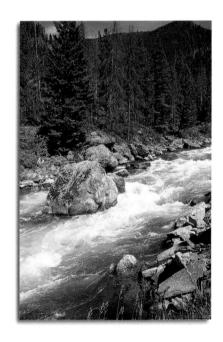

TONAL VALUE PLAN

I made an arrangement as shown in the tonal sketch. I wanted to emphasize the water surging around the rocks. The full tonal range was exploited, from near black to pure white. The dark areas are dominant.

1 When I made the drawing I positioned the large rock to the left and below center. This was the key to the whole layout, everything else was drawn with reference to it.

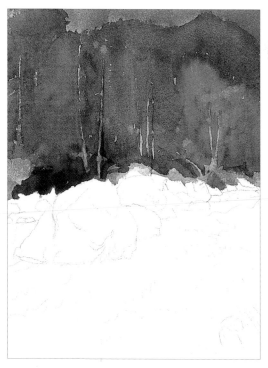

2 The first wash was a mix of Ultramarine Blue and Burnt Sienna in the sky, blending into green with the addition of Aureolin. Water was splashed on the wash was still damp and then blotted off, while leaving a mottled effect.

3 A deeper wash, using the same colors, was started at the mountaintop and again I changed it to various greens. Aureolin, Burnt Sienna were added in places. In some parts Indigo was also dropped in for variation within the wash. Some tree trunks were left with the underlying wash showing through. Then I made a dark tone to introduce strong contrast and to enhance the brilliance of the foaming water.

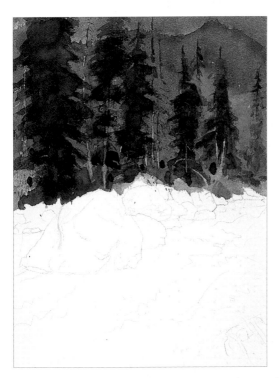

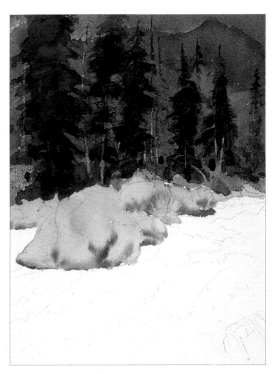

4 The shapes of the fir trees were superimposed over the previous washes using a very strong mix of Indigo and Burnt Sienna.

5 The rocks were given a preliminary wash with Burnt Sienna, Raw Sienna, Indigo and Permanent Rose. These colors were not all used together, but allowed to vary from place to place. The area occupied by the rocks was to become a transition area of tone — a gradation from the dark of the trees to the light of the water — so the overall tone of the rocks had to finish up in the mid-range.

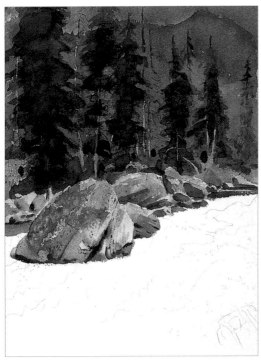

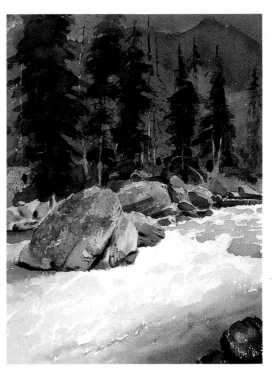

6 I worked on the rocks, modeling, shaping and texturing by dragging, splashing, dabbing and scraping. These techniques require experiment. Remember the lesson on practice. Take a scrap of watercolor paper and experiment. You will find a way. Everyone does. This is the beauty of watercolor. You cannot do it from a recipe. You have to find your own way, learning by doing.

7 The water was Indigo and Phthalo Blue. Burnt Sienna was added in some places where I wanted them to be a little warmer. It was essential to preserve that large area of white to indicate the turbulence of the water. The foam area was left understated. I did not try to include too much detail in here.

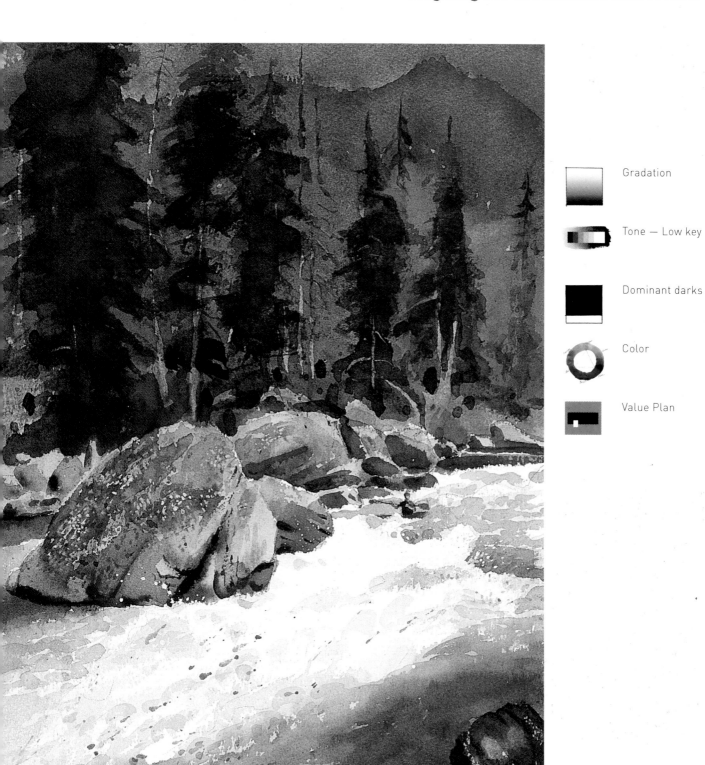

Gradation

Tone — Low key

Dominant darks

Color

Value Plan

8 Color and white gouache were splashed on. I find gouache adds more vitality and movement. While I had the gouache to hand, I added some lichen to the rock by toning the gouache with gray watercolor. The paddler in the kayak was placed strategically so that he did not demand too much attention but made an interesting little complementary red color note.

The most interesting aspect of this painting is the gradation from dark at the top to mid-range then to white and back to dark at the bottom, leaving the white running across at an oblique angle. See how the large rock links the dark and light areas.

Designing seascapes, harbors and boats

This subject requires close observation and plenty of drawing practice, but the results will be deeply satisfying.

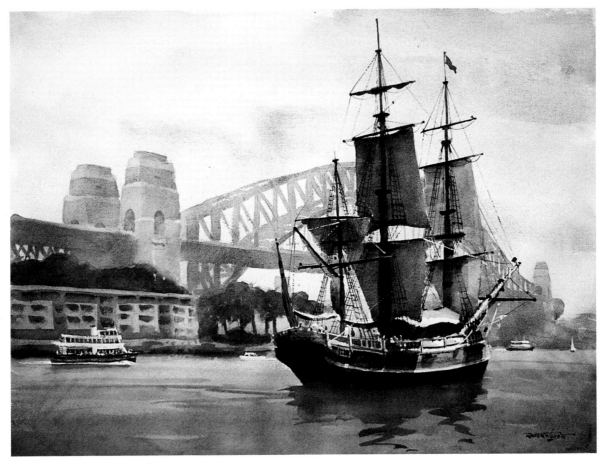

'THE BOUNTY, SYDNEY HARBOUR'

Around the harbors and estuaries you will find a multiplicity of subjects: fishing boats, fisherman, nets and lobster pots, brightly colored floats, and all manner of sailing vessels, presenting you with fascinating challenges. I particularly love to wander around the fishing harbors anywhere in the world. Each country has its own characteristic boats and jetties and methods of fishing. There are still many of the traditional, old style boats in different parts of the world. You should take time to enjoy this environment. Take your sketchbook with you. Draw boats. Draw all kinds of boats from many different angles. See how the perspective applies to the structure. Close observation is essential and attention to proportion is crucial. With practice your skill will improve dramatically.

SIMPLIFYING THE SHAPE
Think of a boat as if it were carved from a block of wood.

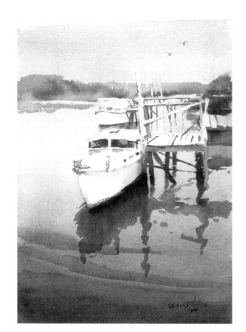

TONAL VALUE PLAN

 Tonal Map

 Gradation

 Contrast

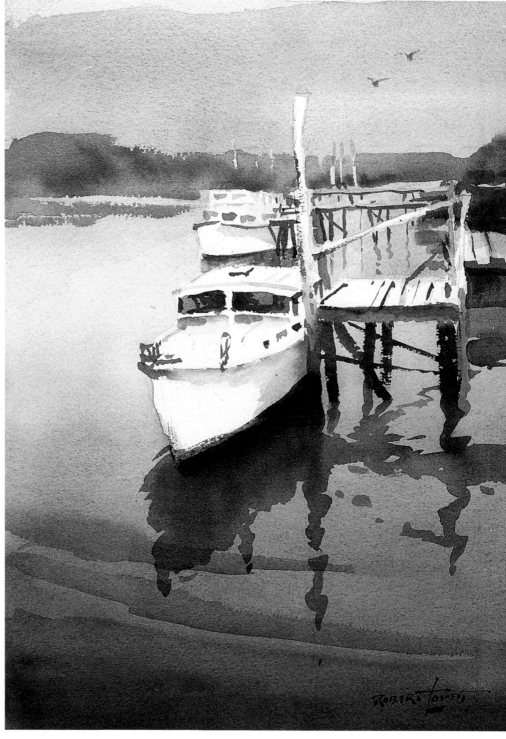

'TIMBER BOAT AT BOONOOROO, QUEENSLAND, AUSTRALIA'
Notice the gradation in tone. The very dark at the bottom retreats in waves
to the lightest light on the boat hulls and jetty.

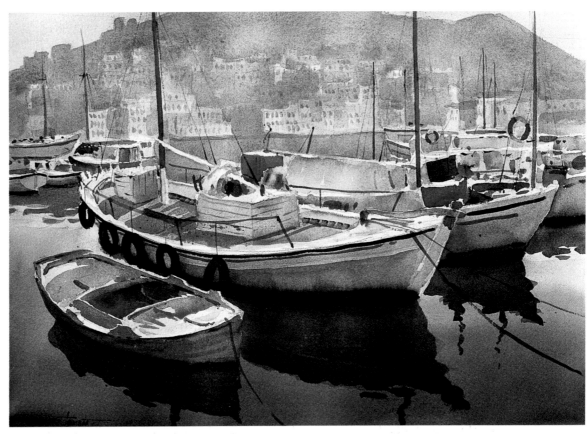

'CALM MORNING, HYDRA, GREECE'

All around the Greek Islands you find graceful, traditional old timber fishing boats. They appear to be suspended on the crystal clear water of the Mediterranean.

Color Repetition Contrast Gradation

TONAL VALUE PLAN

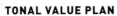

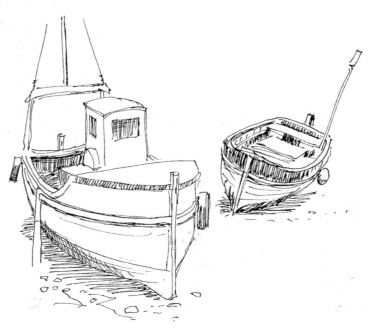

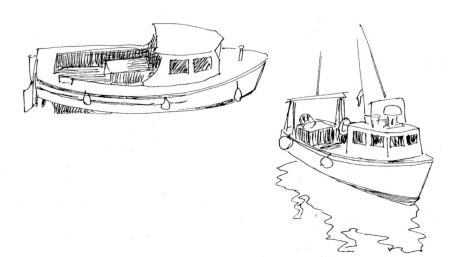

DESIGN PLAN

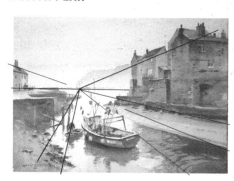

Tonal Map	Direction	Texture	Color	Contrast in size

'STAITHES, YORKSHIRE, ENGLAND'

The boat, the focal area, is the brightest color. To further emphasize its importance, it is surrounded by the lightest tones. It is supported by converging lines, and the background is muted to concentrate attention on the foreground. CONTRAST IN SIZE is used via the man in the dinghy.

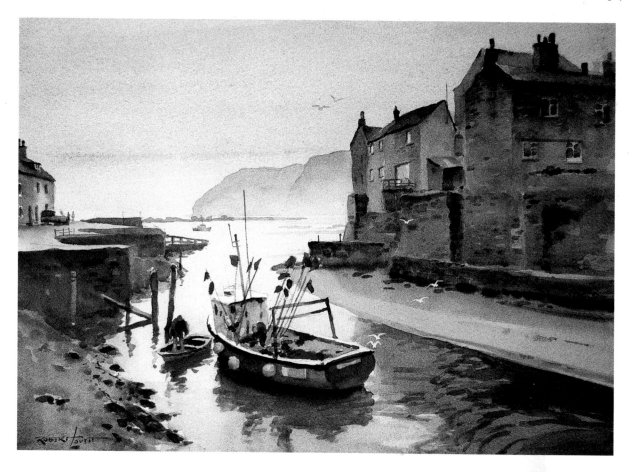

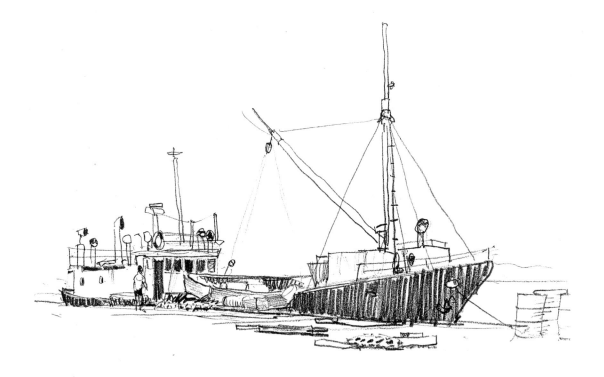

DESIGN PLAN

Shape Color Size Repetition

'MEVAGISSEY'

I enjoyed the repeating color of the floats and the clean, pure shapes of color that lead the eye on a journey of discovery.

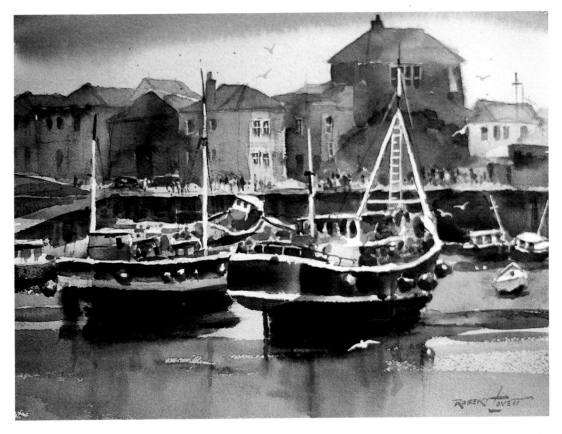

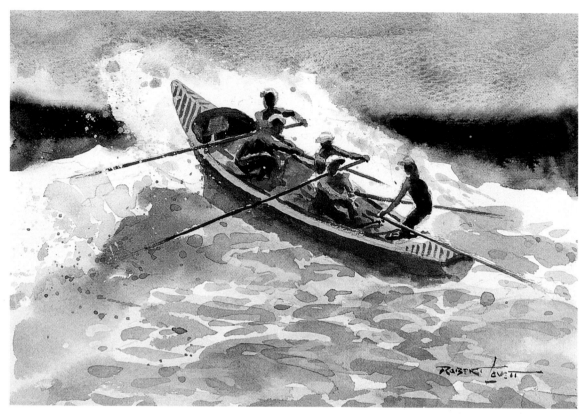

'SURFBOAT I'

Study the water in this sketch — it is a collection of interconnecting shapes. The surf, and the reflections in the water are the lightest lights. I deliberately left the paper untouched in those areas. This is where having a plan pays off.

TONAL VALUE PLAN

Balance

Shape

Texture

Direction

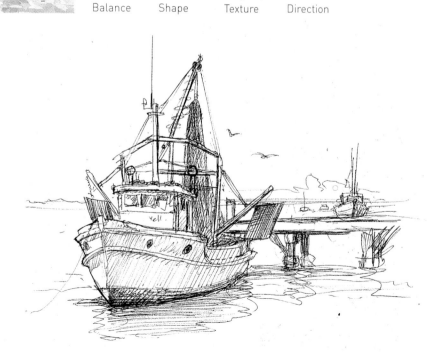

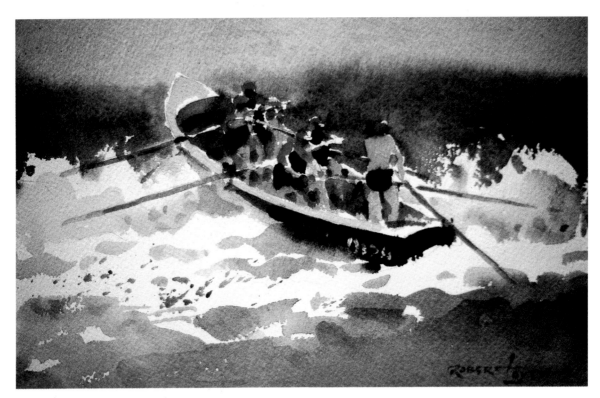

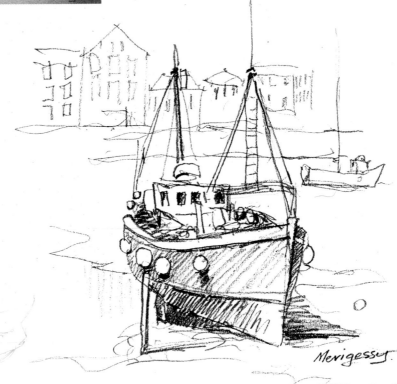

'SURFBOAT II'

See how you can change the mood by altering tones, color and treatment. Even the paper makes a difference. This simple sketch to capture the action was done on rough surface with more diffused washes. See the alternation of light and dark horizontal bands and the powerful contrast where the boat cuts obliquely across.

 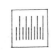

Texture Contrast Alternation

TONAL VALUE PLAN

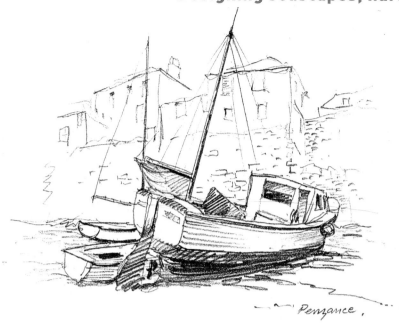

DESIGN PLAN

Informal
Balance

Contrast

Color

Tonal Map

'LOW TIDE, GLADSTONE, QUEENSLAND, AUSTRALIA'
The design plan reveals how I structured this complex scene.

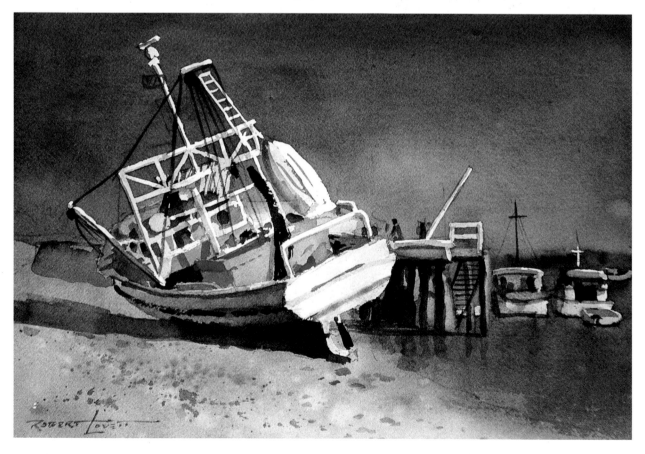

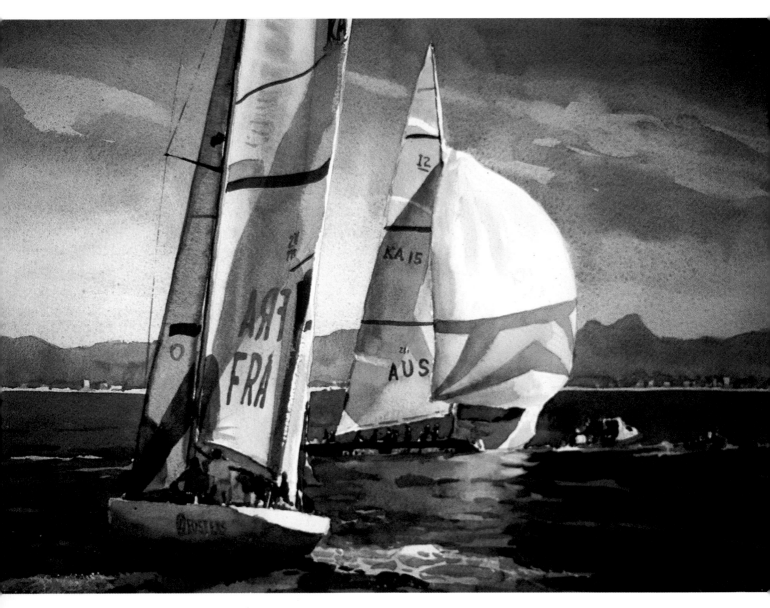

DETAIL

'THE TWELVE METRE YACHTS'

I was fortunate to be present at the America's Cup Trials and painted a series on this theme. My inspiration was the color of the spinnakers and the huge sails.

Color Contrast Texture

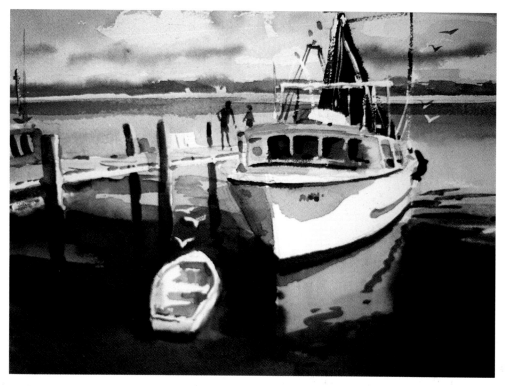

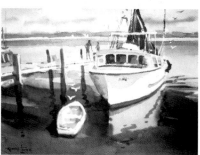

TONAL VALUE PLAN

'THE BROADWATER SOUTHPORT, QUEENSLAND, AUSTRALIA'

Study the treatment of the hull and its reflection in the water. The hull is reserved paper, but I used gouache for the details on the superstructure.

Tone Repetition Gradation

'LOW TIDE MORSTON, NORFOLK, UK'

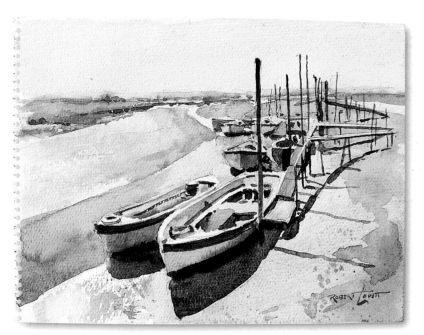

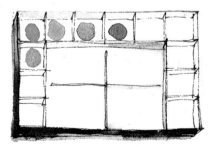
DESIGNING SEASCAPES
Rocky Beach, Australia

CLUES FROM THE SCENE
The seashore provides an infinite variety of subject matter — beaches, rocks, headlands, seagulls and bathers. The many moods of the ocean never fail to inspire. Balmy sunny days, wild storms and rough seas are all possibilities for fantastic subjects.

1 The major rock was set to the left of center. The horizon was set about one-third from the top. I reduced the actual size of the rock in the scene on the far left to allow the major rock to dominate.

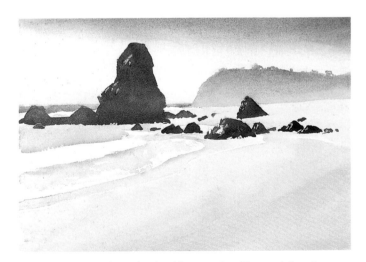

4 The top part of the sky was strengthened using Ultramarine Blue and Burnt Sienna added after wetting. I allowed the color to fuse downwards. The color was not carried down the entire wet area. The sea at the horizon was put in and then softened with a damp brush. Colors for the sea were Ultramarine Blue, Phthalo Blue and Burnt Sienna.

The headland area was wet and the colors dropped in from the top — Ultramarine Blue, Raw Sienna and Permanent Rose. See how they incompletely mixed on the paper making a lovely translucent wash. I kept this lighter at the bottom because there is always some sea spray nearer the ground. This is where your powers of observation will stand you in good stead.

DESIGN PLAN
The main feature is the dominance of the big rock and its contrast in size with the smaller rocks. The mid-tone is also dominant. Direction is basically horizontal but the height of the main rock provides contrast in both direction and tone.

TONAL VALUE MAP

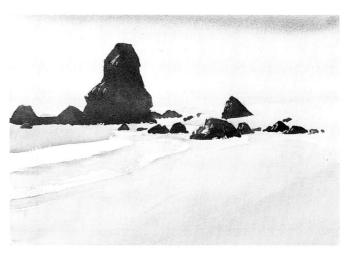

2 The first wash was run from the top, right down the sheet leaving only the white areas of foam. I began with Ultramarine Blue, Burnt Sienna in the sky and introduced some Raw Sienna and Permanent Rose for warmth near the horizon.

I continued the wash down adding Phthalo Blue on the left for the water and Raw Sienna and some Burnt Sienna on the right for the beach. I could have stopped the wash right there but kept going into the shallow, foamy water and the wet sand in the foreground. The same mixture of colors was used there in varying proportions.

3 The rocks were painted using Ultramarine Blue and Burnt Sienna. The colors were allowed to mix on the paper, which gives a nice variation through the wash. I scraped a few highlights with the corner of a credit card while the wash was still wet.

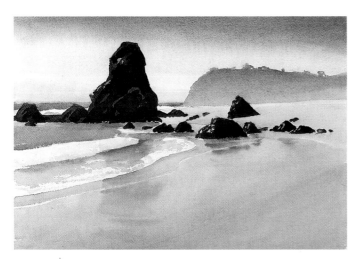

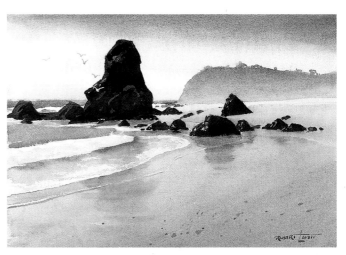

5 Shadows were added to the rocks with Ultramarine Blue and Burnt Sienna. I put a cool gray wash over the lower part of the beach and continued it right down over the wet sand and foreground. While that was wet, the reflections of the rocks were introduced with Ultramarine Blue, Burnt Sienna and Raw Sienna. The main area of blue water on the left, just beneath the rocks, was strengthened. The foam was given some modeling with a neutral gray.

6 Final details, a few little stones in foreground, distant rocks and some seagulls completed the picture. It is a very simple picture with a straightforward design but it seems to capture the salty essence of the beach.

OBJECTIVE

The simple basic design of this painting comprises three horizontal bands, the sky, a central band, (the main subject of objects all massed together) and the sand at the bottom

TECHNIQUES

- Wet-in-wet washes
- Glazes
- Color mixing on the paper

THE TOOLS AND ARRANGEMENTS IN ACTION

 Tone

 Contrast

 Color

 Gradation

 Repetition

WHAT THE ARTIST USED

Paper
Arches 140lb/300gsm Rough

Brushes
No. 12 Squirrel
Round Sables: 12, 8 and 2
1" Flat Sable

Palette
Ultramarine Blue
Cobalt Blue
Aureolin
Permanent Rose
Cadmium Red
Indian Red
Burnt Sienna

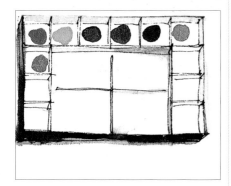

DESIGNING HARBORS AND BOATS

Cadgwith, England

CLUES FROM THE SCENE

The simple, basic design of this painting comprises three horizontal bands: the sky, a central band, (the main objects all massed together) and the sand at the bottom.

1 Although the plan was simple, the drawing was fairly complex, with a mix of buildings and boats.

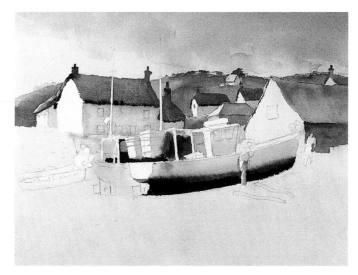

4 The background hill was painted with Cobalt and Aureolin with a touch of Burnt Sienna. The trees were the same mixture, with the addition of Ultramarine Blue.

The white areas in shadow were varied in color based on Cobalt with Permanent Rose, sometimes warmed with Aureolin or Burnt Sienna. The dark base of the main boat was added while the paper was still wet, using Ultramarine Blue and Indian Red.

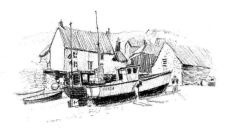

DESIGN PLAN

The dominant tone is mid-range, with darks and lights all placed within the central band. This is where all the activity takes place. It is a busy area in contrast to the calm of the sky and sand areas.

The vertical boat masts provide contrast in direction. The dominant color is a variety of grays but the small bright colors provide contrast and focus.

The sky color was gradated from light at the left to dark at the right. The sand was gradated the opposite way. Those small white areas offset by the nearby dark passages are extremely important.

TONAL VALUE SKETCH

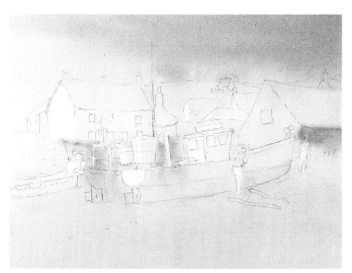

2 I wet the paper with an initial wash of Aureolin and I kept a few areas white.

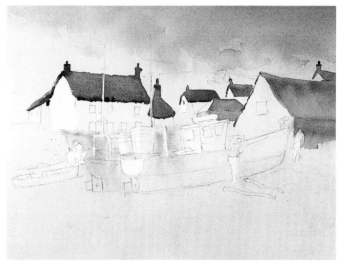

3 Then the rooftops and chimneys were put in using mainly Cobalt Blue and Burnt Sienna. Notice the repeating pattern this forms right across the width of the painting.

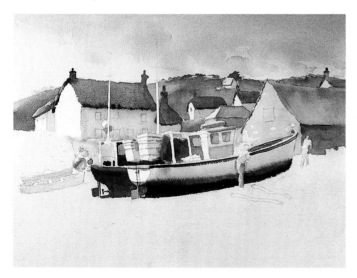

5 The dark boat was put in with strong washes of Cadmium Red, and the multi-colored floats make a real color accent. The end of the large building on the right was darkened a little to subdue it.

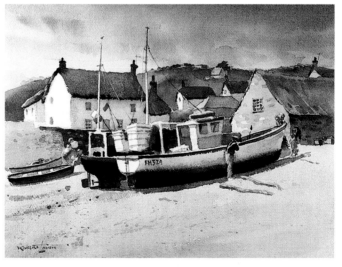

6 Then it was time to add the final details. The tone of the sky was adjusted with another wash, this time using a little Ultramarine Blue and Permanent Rose. A wash was put over the sand, from dark on the left, to almost nothing on the right.

Designing still life and interiors

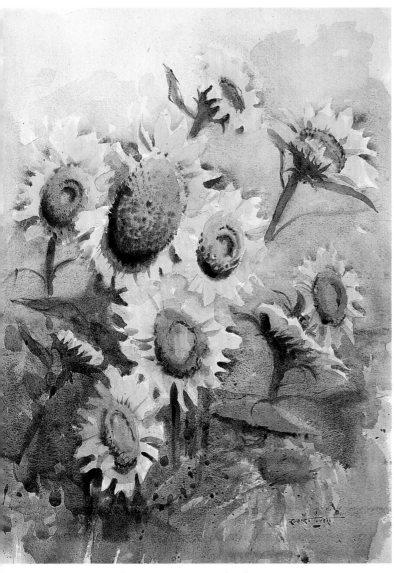

Although we tackle varied subject matter throughout this book, it makes no difference whether it's a seascape, building or figure, we are really only dealing with the tools (the how) and their arrangement (the why) in design. We are using lines, tones, shapes, colors, textures, direction and size no matter what the name of the object we happen to be painting — whether it's a barn or a pumpkin. Your approach to the project in hand is not to consider "How do I paint a seascape?" or "How do I paint a motor car"? You must look at it as an arrangement of shapes tones and colors. So the question becomes "How do I achieve that effect?"

'SUNFLOWERS'

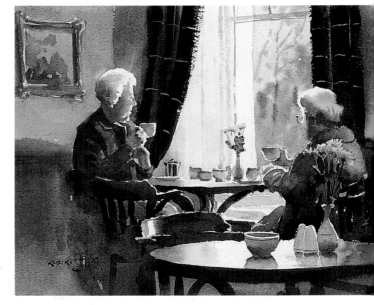

'CUPPA TEA'

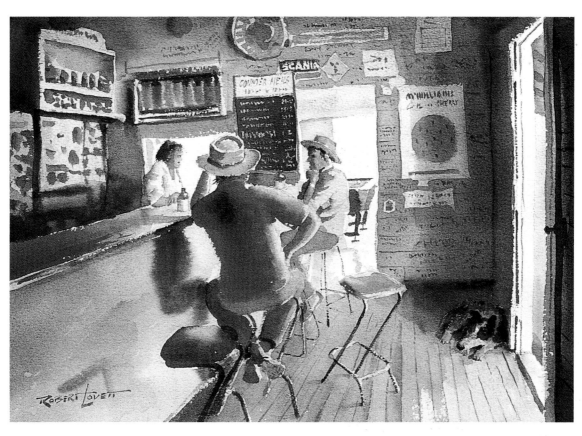

'THE BLUE HEELER PUB'

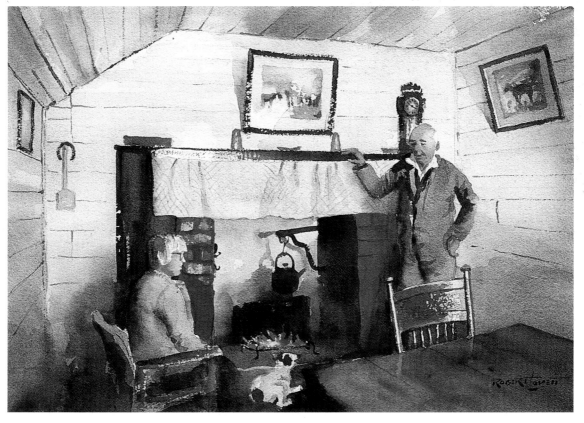

'ROSE'S LIVING ROOM'

To play with backlighting and with light shining through the center of the painting

TECHNIQUE
- Gradated washes
- Blended washes
- Colors mixed on the paper
- Dry brush

THE TOOLS AND ARRANGEMENTS IN ACTION
In this demonstration we pay particular attention to the following design elements:

 Shape
dominance of Round

 Color
dominance of the red yellow

 Tone
dominance of Light tone (High Key)

 Line
dominance of curved lines

 Value pattern

WHAT THE ARTIST USED
Paper
Arches 140 lb/300gsm Medium

Brushes
2" Squirrel Flat
1" Sable Flat
Round Sables: 12, 8 and 2

Palette
Cobalt Blue
Yellow Ochre
Cadmium Yellow
Cadmium Yellow Light
Permanent Rose
Cadmium Red
Cadmium Red Deep
Burnt Sienna

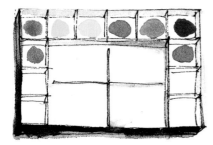

DESIGNING STILL LIFE
Still Life — Fruit and vegetables

Practicing painting still life subjects gives you experience that is essential no matter what subject is tackled. With still life you are able to set up your subject — you can enforce your own design. You have the power to arrange the objects, to use different shaped and colored things to include different textures but, above all, you can manipulate the lighting.

You can practice by arranging the group of objects you have chosen in different lights — strong, harsh light with intense shadows, back light, front and side light. Try soft, subdued lighting. Notice how the lighting effects color.

1 When drawing this subject I was aware of the negative shapes. That is, the shapes between and behind objects. I was also looking for lost edges. We tend to draw what we know instead of what we see. Look at the subject with squinted eyes. This simplifies the tones so that objects seem to blend with one another so you can draw the shapes.

After completing the drawing I went back and erased any contours where tones should be allowed to merge. Usually areas of similar tone can be treated together, even though the colors may differ. You will be pleased to know that great accuracy is not so critical with a subject like fruit and vegetables.

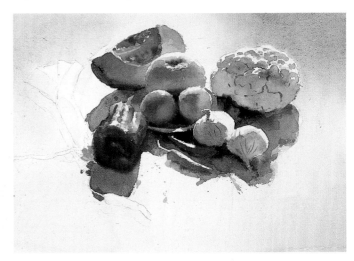

4 The red capsicum was added using Cadmium Red and Cadmium Red Deep. The cast shadow was put in at the same time so the washes blended. Shadows are not separate entities, make them part of the same wash. The colors in the shadow were varied to avoid monotony. The cauliflower was a beautiful off-white and I added some reflected yellow color into its shadow side. On its right I made the shadow quite cool. The onion on the right was treated in the same way.

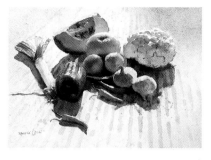

CLUES FROM THE SCENE
Sun streaming in through a window suggested a striped cloth could be used to reinforce the direction of the light. The lines would also lead the eye straight to the collection of fruit and vegetables.

TONAL VALUE PLAN

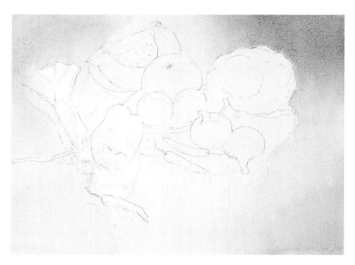

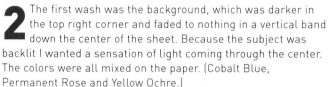

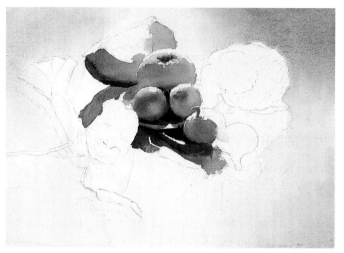

2 The first wash was the background, which was darker in the top right corner and faded to nothing in a vertical band down the center of the sheet. Because the subject was backlit I wanted a sensation of light coming through the center. The colors were all mixed on the paper. (Cobalt Blue, Permanent Rose and Yellow Ochre.)

3 The paper was wet through the central area, and I was careful to avoid wetting the highlight areas. The colors were put into the wet and allowed to blend. You can see the effect of reflected color bouncing into the shadows from the adjacent fruit. Colors used were Cadmium Red, Cadmium Yellow and Cadmium Yellow Light. The shadow sides of the fruit were the same colors, with Cobalt Blue and Burnt Sienna added.

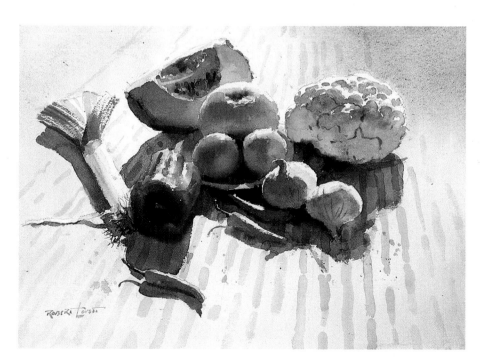

5 The leek leaves were dry-brushed. The leek was mostly defined by its shadow. Final details such as the chillis were added. Some tones were strengthened to reinforce form. The reflected light in the shaded side of all the little spheres again helped to define volume.

TECHNIQUE

- Loose washes
- Gradated washes
- Glazes
- Dragging the brush for rough finish

THE TOOLS AND ARRANGEMENTS IN ACTION

Features of this design are the dominance of the mid-tone and dominance of the warm yellow-red color. Notice the balance of the large medium dark area on the right with the smaller one the left. These medium darks interconnect via the foot of the figure. The light of the window, and its reflection on the floor, makes a vertical shape from top to bottom

 Dominance

 Color

 Informal Balance

 Tonal Value

WHAT THE ARTIST USED

Paper

Arches 140lb/300gsm Medium

Brushes

No. 12 Squirrel
Round Sables: 12, 8 and 2
Sable Flat 1"

Palette

Ultramarine Blue
Cobalt Blue
Raw Sienna
Cadmium Red
Cadmium Yellow
Burnt Sienna
Paynes Gray

DESIGNING INTERIORS

Morning Tea

The interior gives you the opportunity to practice many skills. From a design point of view, the fact that you can achieve complete control over lighting means you have a powerful tool at your disposal.

A lovely backlit effect is possible when daylight is shining through a window. In this case, most of the subject will blend together as one simple shadow mass. Artificial light presents infinite possibilities. It is worth trying a combination of lighting, with cool light from the sky coming in the window, backed up by a warm, artificial, fill-in light. You can travel all over the world in search of subjects but we often overlook what is close and familiar to us. I found this interior scene right here at home.

1 I was very careful with the drawing and it looks tight but I hoped it would loosen up when I began painting. In a scene like this, it is necessary to have your drawing absolutely correct, with particular attention to perspective. If you don't get it right at this stage you cannot correct it as you go along.

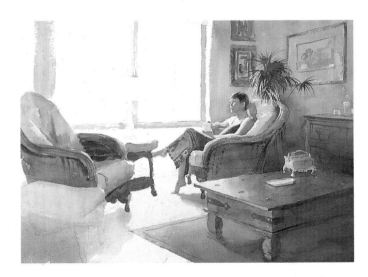

4 I continued down to the coffee table and the red rug using Cadmium Red, Burnt Sienna, Raw Sienna and a little Ultramarine Blue. Notice the gradation on the tabletop and the rug. The color was quite diluted where the light falls on the corner of the rug. I moved over to the left and began working on the chair. I introduced Cadmium Yellow, Raw Sienna, Burnt Sienna and Paynes Gray into the dark areas.

CLUES FROM THE SCENE

The blinds, the square of the window frame intersected by the lamp, the angles of the furniture, the slate tiles, the opportunity for contrast from the indoor plant and the warm glow and reflections offered plenty of incentive.

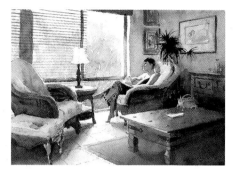

TONAL VALUE PLAN

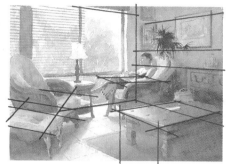

PERSPECTIVE PLAN

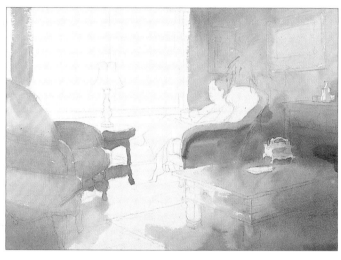

2 As you can see, the first wash was very loose. May I point out that although it is essential to have made an accurate drawing, you do not have to "color-in" between the lines. The lines are there to guide you, not to constrict. Raw Sienna, Burnt Sienna, Cadmium Red and French Ultramarine Blue were used in varying mixtures as the wash proceeded.

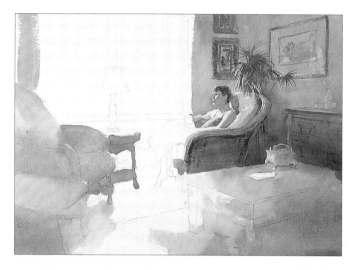

3 I began working on details on the right side, paying special attention to the face, because it is the center of interest. I carefully retained the highlights of the features. I ran another wash over the background making it darker towards the bottom. Pictures and the sideboard were put in by dragging the brush to give a rough finish.

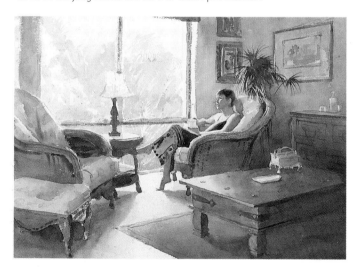

5 The floor was treated with gradated washes of Indian Red and Cadmium Red and Paynes Gray. I wanted to preserve the light reflecting across the tiles. I worked more on the chair and stool on the left. Then moved to the garden area with some Cobalt Blue and Cadmium Yellow. The plants were indicated with a VERY light wash to keep the outdoors in a sunlit, high key.

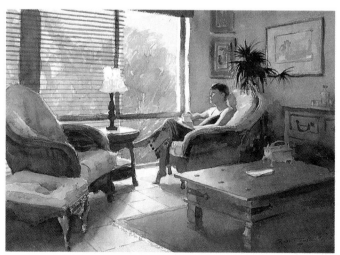

6 Then it was just a matter of adding the final details. The blind slats were put in with a rigger brush. (A rigger is a fine, long-haired brush, that can be dragged to make long thin lines.) Have a look at the perspective of these slats. See if you can find the vanishing point and eye level in this scene.

OBJECTIVE
To play with light and texture to create a warm, inviting scene full of the atmosphere of Italy

TECHNIQUE
- Wet-into-wet washes
- Glazes
- Dry brush

THE TOOLS AND ARRANGEMENTS IN ACTION

 Contrast

 Shape

 Line

 Color

 Dominance

 Value

WHAT THE ARTIST USED
Paper
Arches 140lb/300gsm Rough

Brushes
No. 12 Squirrel
Round Sables: 12, 8 and 2
½" Flat Sable

Palette
Ultramarine Blue
Aureolin
Raw Sienna
Permanent Rose
Indian Red
Indigo

DESIGNING INTERIORS
Italian Villa

CLUES FROM THE SCENE

The 200 year old Villa where we stayed for three weeks in a small village called Tarzo in Northern Italy, had a lot of charm and character. The warm light streaming in through the door to the dark interior suggested a warm/cool color opportunity.

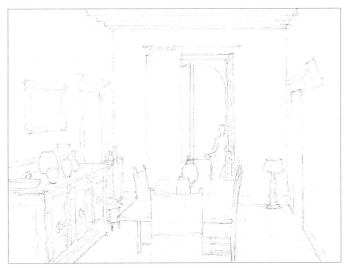

1 Although the drawing on 300 gsm Rough paper was straightforward, with single point perspective, it had to be accurate.

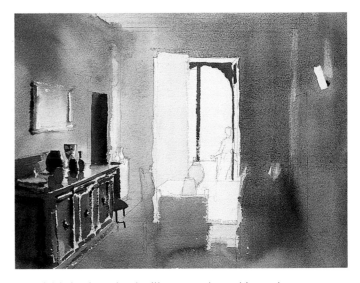

4 The sideboard was fairly intricate but I still managed to achieve a loose result by using dry brush effects in parts, and wet-into-wet in other areas. Ultramarine Blue and Indian Red were the main colors used here. The still life collection of vases had various colors like Permanent Rose, Raw Sienna as well as the Ultramarine Blue.

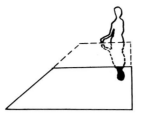

WHAT'S GOING ON HERE?

You may wonder why only the head of the figure reflects in the table. The diagram explains. If the table continued through to meet the figure you would have a reflection of all that part above the tabletop. The table, being shorter, only reflects part of the image.

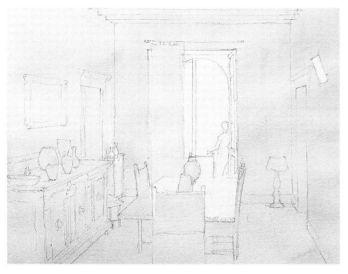

2 A light wash of Indigo, Aureolin and Permanent Rose covered the paper, with the exception of the light coming in the doorway and the reflection on the glass tabletop.

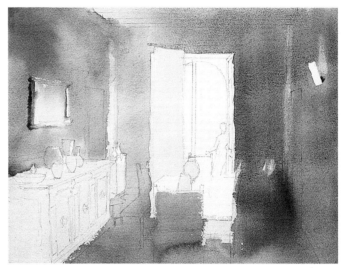

3 A stronger wash was applied over the previous one, this time introducing a little Burnt Sienna in places to add warmth. The sideboard was to receive individual treatment later. The light parts of the picture on the wall were retained and the darker shadows were added while the wash was still wet using Ultramarine Blue and Raw Sienna.

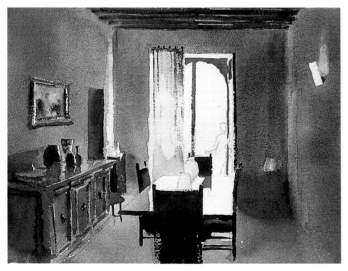

5 The table and chairs shared the same colors and treatment as the sideboard. See how the little highlights were left at the top of the chairs. The curtain was darkened at the top and bottom with Raw Sienna toned down with some gray from the palette leftovers. The folds were dragged on with a small brush giving that broken look. The timber beams across the ceiling were partly dragged, partly wet-in-wet to give a rough finish. Ultramarine Blue and Indian Red were the colors. The small cabinet in the left corner and the lamp in the other corner were all treated as little still life subjects.

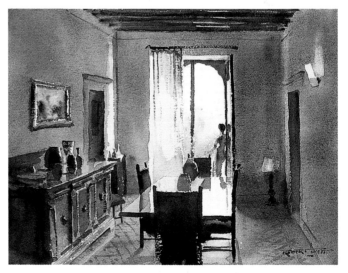

6 The figure was painted using the same technique with ragged edges but the colors were fused wet. See the reflections in the open door and on the tabletop. Vases on the table and patterns on the floor complete the picture.

Chapter 10

Designing figures and animals

When you are capturing living things that rarely sit still, first impressions count. Drawing skill and a knowledge of anatomy will come in handy too.

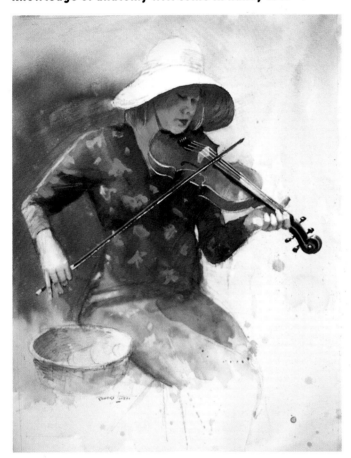

'THE BUSKER, SAN FRANCISCO'

The human figure is one of the great challenges for the artist and is probably the best discipline for honing your drawing and painting skills. If you choose to take up this challenge it can be very rewarding. I recommend that you join a life drawing class where you can work directly from the model. Sharing your interest with the other students and comparing and critiquing one another's work can also be very helpful.

Animals present a different test — they rarely stay still, even if you command them to. Here is where you develop your sketching skills to their fullest. And your patience. Common to both figures and animals is their underlying structure, so if you're serious about painting them, learn some anatomy and be a constant student of their movements, how the muscles look, and their proportions.

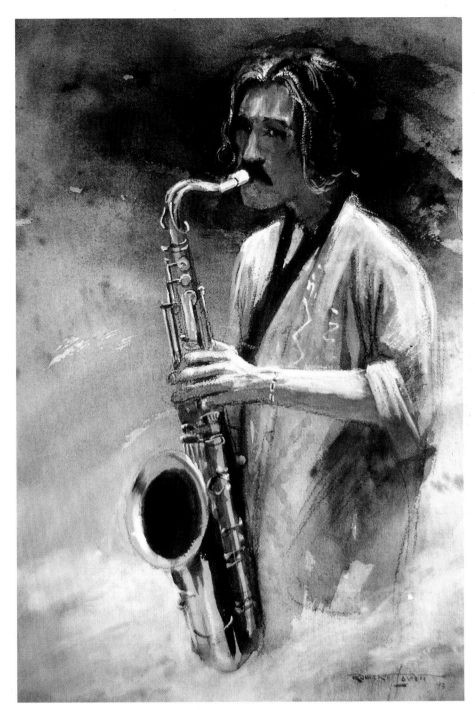

'THE SAX PLAYER'

OBJECTIVE

I wanted to capture the soft forms of the figure contrasting with the hard shapes of the chair. I also wanted unity, so repeated the hair color in the chair

TECHNIQUE

- Wet-in-wet
- Wet-on-dry

THE TOOLS AND ARRANGEMENTS IN ACTION

 Tone — Dominance of the mid tone

 Line — Dominance of curves. There is only one straight line

 Direction — Vertical and oblique. There is no horizontal

 Color — Dominance of warm colors with a little of the cool in the background for contrast

WHAT THE ARTIST USED

Paper
Arches 140lb/300gsm Cold Press

Brushes
2" Squirrel Flat
Round Squirrel No. 12
Round Sables: 12, 8 and 2

Palette
Cobalt Blue
Cerulean Blue
Raw Sienna
Permanent Rose
Cadmium Red
Indian Red
Burnt Sienna

DESIGNING FIGURES
Nude

CLUES FROM THE SCENE

In life class time is limited so the first impression counts. In this case it was the soft light on the model's skin and chair that suggested soft edges and a fast, loose sketch.

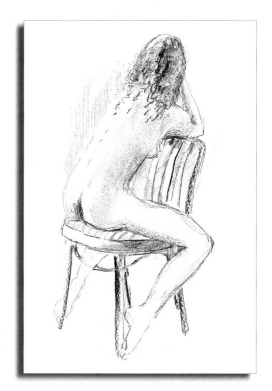

1 The original charcoal drawing came from a 30-minute pose during a life drawing session.

4 Again I started on the left side of the background working straight onto dry paper with the Cobalt Blue, Raw Sienna and Permanent Rose mixture. This was continued across the top and down over the hair, leaving a few highlights. Darker flesh tones were added to the figure as I carefully shaped the subtle parts of the back.

2 I transferred my drawing to the watercolor paper simply by tracing it.

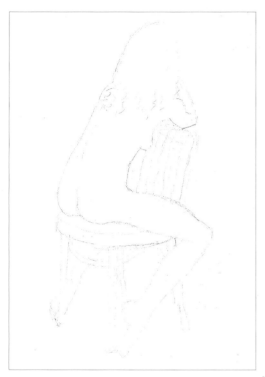

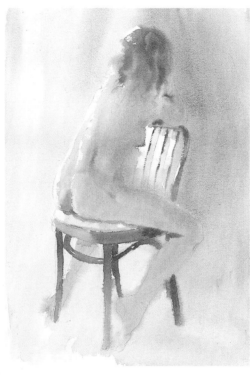

3 Everything you see at this stage was put in at once while wet. I put a wash all over the sheet, leaving some small highlights down the left side of the torso and a few slats on the chair where I wanted to retain light. I then began with the background on the left and used Raw Sienna and Cerulean Blue. As I worked my way across to the right, I changed to Burnt Sienna, Cobalt Blue and Permanent Rose, and sometimes Raw Sienna. I used the same colors for the hair. The flesh tones were Cadmium Red, Burnt Sienna and Raw Sienna. This was all put in wet and most of the edges were soft except for those highlights which were not wet at first. The chair was dragged in quickly with Burnt Sienna and Cobalt Blue and Raw Sienna. The pigment in this area fused where the paper was still wet and produced a ragged edge where it had dried.

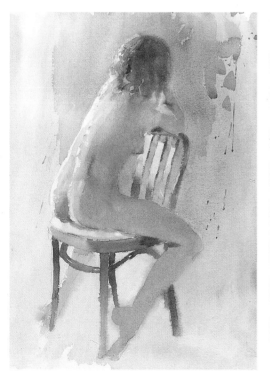

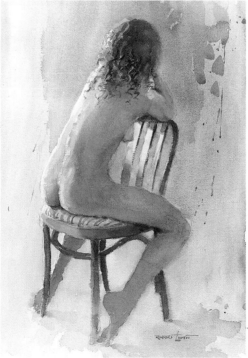

5 The background was extended down to the lower area over the chair legs. The flesh tones were strengthened on the legs and I tried to keep some soft edges. The chair legs were made a little darker and again the edges were maintained, whether soft or rough. Details of hair and cushion were added, a few little corrections were made to the figure tones and that carried it far enough. This was a quick watercolor that I tried to keep fairly loose.

Designing animals

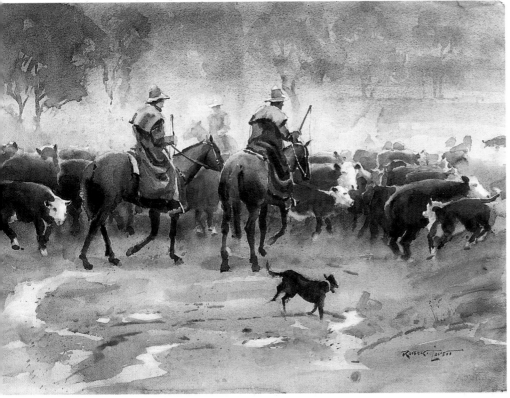

'WET DAY ROUNDUP'

Drawing horses, or any animals, is daunting for some people. But if it is your desire is to do this then constant study and practice will make it much easier. Knowledge is the key, and knowledge is gained by diligent work. I know this from experience because I found animals a difficult subject when I first began many years ago. However, I was determined to master the subject. I studied three-dimensional anatomy, which led me to sculpture, which certainly helped me to understand form. I constantly drew horses and cattle, lots of dogs, and other animals as well. I once made an instructional video on painting horses in which I said, " You should run your hands over the horse to feel and understand its form". I have received much derision ever since. People ask, "Is the principle the same for the human figure? Do you run your hands over your models?"

'MOUNTAIN HORSEMEN'

Well the horse didn't object.

But, seriously, you need at least a rudimentary knowledge of anatomy. Drawing animals must be a pleasure for you and not a chore Study the way they move, how horses gallop and trot or just the way animals walk. Look at the way their muscles ripple with movement and how the light works on a shiny coat. It can becomes a fascinating, absorbing pursuit.

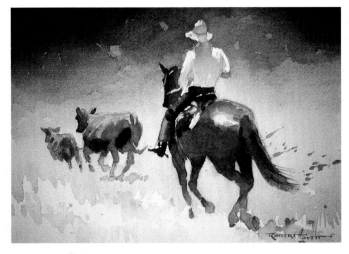

'THE STRAYS'

'ON GLENROCK STATION'

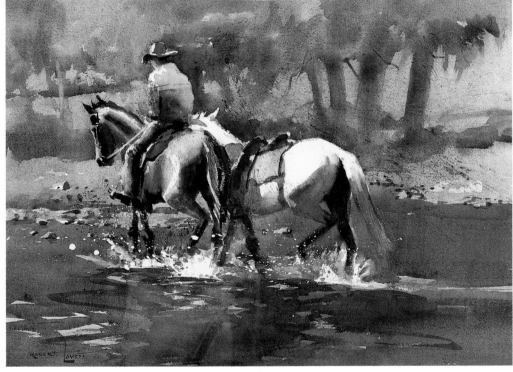

'JABIRU'

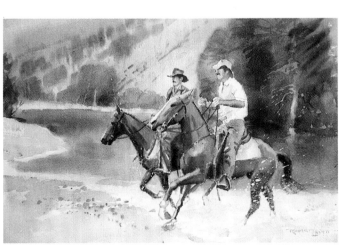

'THE HUNTER VALLEY HORSEMEN'

OBJECTIVE

This was a study to suggest movement and still retain some regard to the horse's anatomy

The interesting feature is the contrast of color — the warm red-browns of the horse and the bright yellows against the cool blues and greens of the background

TECHNIQUE

- Wet-into-wet

THE TOOLS AND ARRANGEMENTS IN ACTION

 Contrast

 Color

 Shape

 Direction

 Tonal Map — The mid-tone is dominant, the darks not nearly as dominant and the lights are minimal

WHAT THE ARTIST USED

Paper
Arches 140 lb/300gsm Cold Press

Brushes
Round Sables: 12, 8 and 2
Sable Flats
2½" Housepainter's Brush

Palette
Ultramarine Blue
Hookers Green
Yellow Ochre
Cadmium Yellow
Cadmium Red Deep
Burnt Sienna

DESIGNING ANIMALS

Racehorse

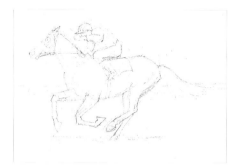

1 I made my drawing then transferred it to the paper.

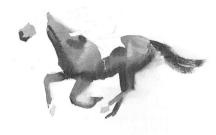

2 The horse's body was given a wash of Burnt Sienna and Cadmium Red Deep. Water was applied outside of the rear edges and just touching the wash so that the color fused, giving a sense of movement right from the start.

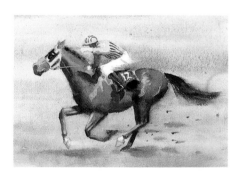

6 A wash of French Ultramarine Blue and a little Cadmium Red Deep was put all over the background avoiding the jockey. This was carried down into the shadow areas of the horse and across the horse's legs as it changed color with the addition of Hookers Green and some Yellow Ochre. The shadow on the jockey's pants was added and allowed to blend into the background.

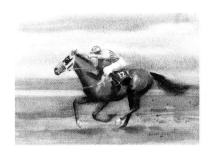

CLUES FROM THE SCENE

This study was all about speed — but I also wanted an accurate portrayal of the movement of the horse. As a bonus, I could also enjoy drawing the jockey as he urged his mount onward. Kentucky Derby anyone?

TONAL VALUE PLAN

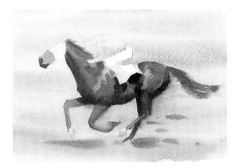

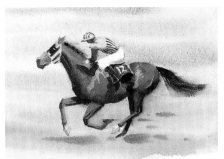

3 A darker wash of the same colors was overlaid leaving the shiny parts of the horse's coat. Ultramarine Blue was added in the shadow areas, and again I allowed it to blend to the right by wetting that area.

4 A wash of Yellow Ochre was applied all the way over the sheet, but avoiding the jockey's pants and saddlecloth which remained white. Immediately, Ultramarine Blue and Burnt Sienna were introduced in long horizontal streaks at the top, with Hookers Green and Burnt Sienna towards the bottom. As this wash carried across the previously painted horse the color was picked up. I turned the board so that it sloped down to the right allowing these colors to run in that direction, creating more sense of speed.

5 Cadmium Yellow was used for the jockey's colors. A mixture of French Ultramarine Blue and Burnt Sienna was used for the black stripes, which were added while the area was still damp. The shadows on the yellow were mixed with Cadmium Yellow, Burnt Sienna and Ultramarine Blue. Notice how the yellow retains its identity in shadow. Shadow details on the horse's neck and legs were intensified with Ultramarine Blue and Burnt Sienna and Cadmium Red Deep.

7 Stripes of Burnt Sienna and Hookers Green were dragged horizontally across the middle of the picture with a house painting brush. This darkened the area but retained the sense of speed.

8 Further details were added. Whip, reins, straps, and other details were put in using various means, washing out or by applying gouache with a fine brush.

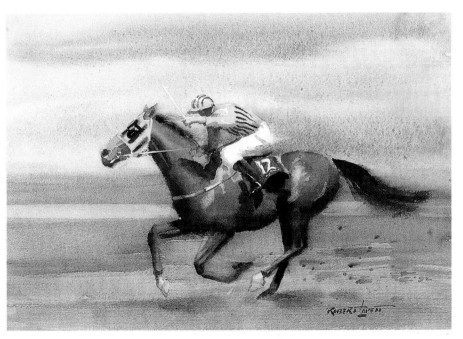

OBJECTIVE

I enjoy polo matches because of the action and the chance to see those magnificent horses at their best. Not just full gallop but the way they turn and prop and change direction is a visual feast for me. These horses seem to be in tune with the very thoughts of their riders. This little study was an attempt to capture the feeling of the action and movement.

TECHNIQUE

- Wet-in-wet
- Gradated washes
- Paper cut-out template to confine and wash areas

THE TOOLS AND ARRANGEMENTS IN ACTION

 Tone

 Contrast

 Alternation

 Shape

 Balance

WHAT THE ARTIST USED

Paper
Arches 300lb/600gsm Heavyweight

Brushes
No. 12 Squirrel
Round Sables: 12, 8 and 2
Small bristle brush for washing out

Palette
Ultramarine Blue
Hookers Green
Raw Sienna
Cadmium Yellow
Permanent Rose
Cadmium Red
Burnt Sienna

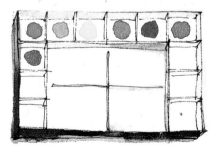

DESIGNING FIGURES AND ANIMALS

Polo

CLUES FROM THE SCENE

Plenty of action here but, from a design point of view, the gray pony needed to be brought into the group to make a central shape that would give unity to my subject. Blurring the two horses in the back of the group rendered them less important and emphasized the gray horse even more. As the largest light object, this shape would call attention to itself anyway.

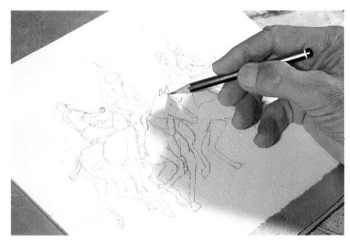

1 Because of my years of experience, drawing horses is one of the things I can do with relative ease.

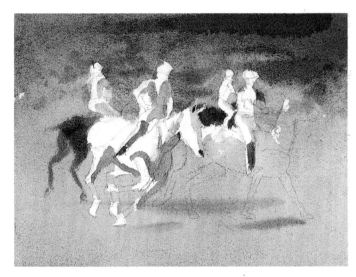

4 I worked in some of the darks of the two horses at the back, allowing the edges to fuse. Some blue-gray shadows were added to the white clothing and horse.

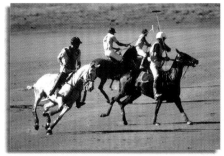

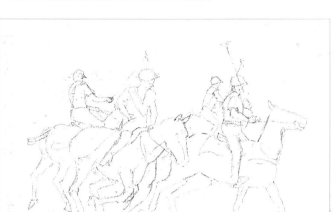

3 The paper was heavyweight 600 gsm that I had soaked in water and worked on wet for the entire time. A wash of Ultramarine Blue and Permanent Rose was started very heavy at the top. This was graduated down to a lighter tone with some Raw Sienna and Hookers Green. I avoided all the white areas and, in spite of the saturated paper, they held their edges.

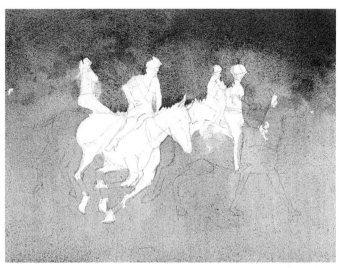

2 You will see by referring to the photograph above that I moved the gray polo pony in closer to make a better tonal arrangement and to put him in a better position as the focal point of the design. With his nose overlapping the dark horse to the right there is a better sense of three-dimensions. I also changed the angle of the polo mallet on the left so it leaned in to the design, completing the vague, circular shape. Compare the finished painting with the original photograph and you will see what I mean.

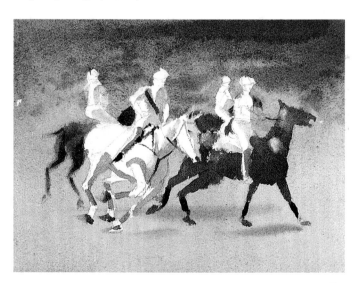

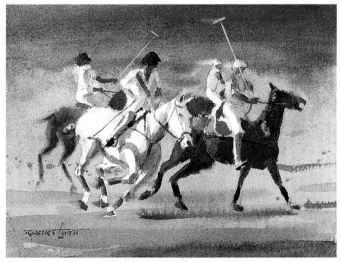

5 The dark horse on the right was put in with a heavy wash, but not too wet. Some edges fused into the background while others showed a dry brush roughness.

6 Cadmium Yellow shirts and Cadmium Red saddlecloths were put in for some bright color notes. Helmets, hoofs and bridles were are all drawn with a small brush but were still treated as a wash. The mallets and shafts were washed out, then used a small bristle brush and dabbed with a tissue to remove pigment. I used a paper cut-out template to confine the area to be washed. This painting was executed very quickly. I wanted it to have a spontaneous dashed-off look. It seems to have captured a sense of movement.

Conclusion

The pleasure of painting is in the journey not the destination. It has become apparent to me that there is no arriving. Painting is a lifelong quest. The more I paint the more it seems there is to learn. That's the fascination — the anticipation of the next great picture.

I have tried to show you some of my thinking in designing and developing a painting. You should now be seeing in terms of the Tools and their Arrangement. You will carry this body of understanding with you every day. When you visit art galleries you can analyze and criticize the paintings from a basis of knowledge. And, knowing the creative mind, before too long it will become a habit to mentally organize everything you see into these same design principles — you will be practicing design as you go about your daily life. Then, when you sit down to draw, sketch and paint you will be able to design your paintings with knowledge and confidence.

There are numerous demonstrations in the book that give an insight into my working methods. I hope these will be helpful to you. I believe it will help you if you revisit them after a few months and tackle them again. I am sure you will be delighted to find you have a greater understanding of the entire design process.

That is my way of working. There are many other ways. I invite you take what you want from the book and no doubt you will eventually develop your own style and technique.

There are two more things apart from a design sense that I hope you will take with you.

First, don't ever forget that practice makes perfect. So PRACTICE!

Second, DRAW. Carry a little pocket sketchbook and draw at every opportunity.

While you are doing these things, please, enjoy yourself!

You may like to check my website now and then. It will show all of my latest paintings and continue to give some tips and tuition.

www.lovettart.com